THE VIEW FROM THE STUDIO DOOR

THE VIEW
From The Studio Door

How Artists Find Their Way
In An Uncertain World

by
Ted Orland

IMAGE CONTINUUM PRESS
SANTA CRUZ, CALIFORNIA & EUGENE, OREGON

ISBN: 978-0-9614547-5-3

Library of Congress Control Number: 2005907686

Published by The Image Continuum Press

Distributed to the trade by
Consortium Book Sales & Distribution
(800) 283-3572

Cover Illustration
The Gates of Paradise by Ted Orland

Printed in the USA by McNaughton & Gunn
(with special thanks to Karl Frauhammer)

2006 First Release
2007 2nd printing [v.2.0] (revised & enlarged)
2008 3rd printing [v3.0]
2010 4th printing

Contents

ABOUT THE VIEW

Books should not be
made from other books
— the author should
have *been there*.
— Henry David Thoreau

This is a book about the nature of artmaking. More precisely, it's about the nature of artmaking as seen from the artist's perspective — drawn from life and seasoned with experiences in the real world. It is, in essence, the view from my studio door.

Naturally, that also makes it a fairly personal effort. In fact I began this project by thinking about what I had learned as a beginning artist — or more accurately, what I *wish* I had learned. I realize now that it's taken me the better part of my adult life to fully appreciate that as artists we are all fellow travelers — all making our way down a common path, all encountering the same obstacles as we try to build and sustain a life for ourselves in the arts.

So I wanted to see if I could lay the groundwork for a practical philosophy of artmaking, something that would be helpful to any and all of us who make art on a continuing basis. I wanted to understand the questions we need to engage as artists if we are to make art that matches our sense of the world, art that makes a difference to ourselves and others. And truthfully, what could be more important for any of us — art makers or otherwise — than to make

work that matters to us, work so important that we give up other things in our lives to do it?

Several years ago David Bayles invited me to collaborate with him on a small book we titled *Art & Fear*. In that book we focused directly on the day-to-day obstacles that artists face when they sit down at their easel or keyboard and try to get at the work they need to do. We explored how art gets made, why it often doesn't get made, and the nature of the difficulties that cause so many artists to give up along the way. David & I share the conviction that the essential first step to building a life in the arts is simply getting past the obstacles that keep that initial brush stroke from ever reaching the canvas in the first place. It may sound old-fashioned, but at least by my accounting you're only allowed to call yourself an artist if you *actually make art*.

In the next hundred pages, however, I want to take aim on the issues that lie to either side of that artistic moment of truth. To one side there are large philosophical questions about the fundamental nature of artmaking. *How do we make sense of the world? What are we really doing when we make art? And for that matter, what is art, anyway?* And to the other side there are tangible, gritty, real-world questions that today's artists encounter the moment they're off the starting blocks and producing work on a regular basis. *Is there art after graduation? Where's the audience hiding? And how do we find our place in the artistic community?*

In many respects, asking questions about artmaking is a lot like artmaking itself: the product of one inquiry becomes

These questions would probably leave you completely paralyzed if you asked them while standing at your easel, paintbrush in hand. But if you *never* engage the large questions you may lose (or never develop) the desire to pick up a paintbrush in the first place.

the source for the next. Some of the best art questions are less useful for the answers they yield than for the questions they generate. Many other art questions do offer a single perfect answer — but for each artist, paradoxically, a different perfect answer. Part of the fascination with such questions lies in their reflexive, almost self-aware quality. *Only you can say what color the sky in your painting needs to be. And only that sky, once painted, can inform you of the subtle influence its light* must *exert upon the landscape below.*

That small illustration points up a much larger artistic truth: that for the artist, theory and practice are *always* intertwined. And that applies not only to the relationship between art and artist, but also more generally to the relationship between art and society. Artists today stand at the edge of an uncertain world, where the promise of art runs headlong into the difficulty of practicing that art. Perhaps the most basic challenge facing artists today is bridging the gulf that now isolates art from society.

That task becomes easier (and in fact may only be possible) when artists are surrounded by a community that supports and values the work they're trying to do. So while *The View* opens with a broad overview on the nature of artmaking, it closes with specific strategies for finding or creating just such a community — a community of artists.

And beyond that, I'd like to think that *The View* is itself an experiment in community — a kind of slow-motion conversation, like chess by mail. That's what the wide margins on these pages are all about. My hope is that you'll

3

fill that space with the ideas & questions & discoveries & experiences that frame the view from *your* studio door. In the book's *Afterword* I've listed an internet link for reaching me with any ideas you're willing to share. My hope, simply put, is that over time *The View* will evolve into a shared conversation on the nature of artmaking. Come join the conversation....

TED ORLAND

Some of the ideas found in *this* copy of *The View* came from readers of previous editions.

For David & the Salonistas

Hello!
My name's Polly!
I can talk!
 Can you *fly*?
 – Greeting from
 a friend's parrot

MAKING SENSE
OF THE WORLD

Time flies like an arrow.
Fruit flies like a banana.
— Groucho Marx

 HAVE A CAT NAMED "FEATHER". Feather is affectionate, playful, curious, fiercely independent — in fact she pretty much does whatever she damn well pleases. Feather does not, however, make art. At least not by any conventional definition of the term. Now that in itself is curious, because Feather & I otherwise share all manner of quirks and habits and personal preferences — traits that are part and parcel of what we commonly call free will. And beyond that we're both common-sense theorists, wrestling moment by moment with the ongoing necessity of making sense of the world around us. That's just to say that even Feather, responding to a rustle in the tall grass nearby, is acting on a theory — *her* theory — about how the world works.

Now in the cat world, decision-making is breathtakingly direct: Feather listens; Feather pounces. And from the outside it all looks pretty much like a textbook example of pure biochemistry at work — a perfect unity of stimulus and response requiring no conscious reasoning whatsoever. At least that's my take on it, since I don't quite picture Feather laying awake nights pondering the moral implications of — well, of ripping some poor defenseless little mousie to shreds.

Yet while our respective minds may be wildly different on the inside, both give rise to actions that are equally appropriate for meeting our needs on the outside. Simply put, both cats and people do the best they can to cope with the world as they perceive it. What that really suggests is that decision-making — as a process — stretches seamlessly from instinct to intellect. Cats hunt; mice reproduce faster than they get eaten; people think. And even if our own thought processes are different from those of other creatures, *it doesn't matter* — there are many possible frameworks on which to hang the meaning of the world.

Admittedly, on a day-to-day basis it may hardly matter whether one's belief system is more closely aligned with the *I Ching* or the Psychic Hotline. Almost any approach having a consistent internal framework will yield passable results.

Our own mental framework, however, also displays an additional trait — namely, a highly visible capacity for what we've come to call "artmaking". Indeed, making art is widely viewed as a uniquely human activity. But you do have to wonder: If animals don't make art, why not? Are we really alone in that realm, or have we simply crafted the definition of art in a manner that reinforces our self-proclaimed perch atop the evolutionary tree?

8

And even if we have, does it really make any difference? Viewed across a larger spectrum, we probably *are* qualitatively different from the rest of the animal kingdom — witness our singular capacity for language, symbolism, abstract thinking and heightened consciousness.

It seems entirely plausible that one (or some combination) of those qualities triggers our capacity for artmaking. Consciousness — especially in its highly distilled state of self-awareness — seems the most likely candidate, although a satisfying explanation for just why that should be so remains elusive. Perhaps someday the questions about the role of consciousness in artmaking will all be resolved — but then again, perhaps not. As one neurosurgeon pessimistically noted, "If our brain were simple enough to be understood, we'd be too simple to understand it".

Viewed dispassionately, it could be that making art is merely our way of compensating for the evolutionary *failure* of consciousness. Perhaps our conscious separation of the world into self and not-self makes it impossible for us to immerse ourselves in the totality of experience, and so we try to recapture that totality through our art. So it could be that Feather (remember Feather?), having never stepped away from the direct experience of her environment, has no need to go back and find it. If cats and their fellow critters don't make art, perhaps it's because they don't need to.

People, however, *do*. And for artists, that imperative opens the door to a tangibly useful question: *What are we actually* doing *when we make art?* Resolving uncertainty?

Then there's astronomer Sir Arthur Eddington's observation at the other end of the cosmological spectrum – namely, that the universe is not only stranger than we imagine, it's stranger than we *can* imagine.

9

Giving form to our experiences? Seeking emotional release? Declaring what we believe important? Expressing our belief system?

But if artmaking is the inevitable pursuit of our species, why doesn't everyone do it?

Well, all of the above and more, no doubt. Each of us, over time, develops our own understanding and sense of purpose for the work we need to do. Consider the watercolorist I happened upon at her easel in the field one afternoon. She reflected on that very question for a full minute as her eyes skipped back and forth, comparing her painted landscape with its nearby source.

"What am I really doing?", she mused. "Learning and remembering."

In that same manner we each construct our own mental map of the world, its major landmarks already drawn in at birth — coded into our genes — while vast blank areas wait to be filled in from experience. Given time, we have the potential to fill this map with rich and dense connections, opening a passage from facts to ideas, from knowledge to wisdom. At some deep level artmaking integrates the things we learn to be true with the things we have always known to be true. Finding that correlation between instinct and experience is the key to drawing out universal truths from particular experiences. It's all a matter of learning and remembering.

Literally speaking, of course, the map of the territory is not the territory itself. It never is. But it is a powerful metaphor — and more importantly, a useful one. Imagine: one unique map — *yours* — guiding you to the discoveries that are yours alone to make.

10

My friend David Bayles tells a marvelous story in that regard. "I once accompanied an experienced mushroom hunter on a walk in the woods", he recalls. "It wasn't a mushroom hunt, mind you, just a casual walk in the woods. Nonetheless, it was astonishing: within minutes it became abundantly clear that the mushroom hunter not only lived in a world that had more mushrooms than mine, she lived in a world where the routes toward mushrooms were clear and visible. Where I saw a chaotic tangle of moss and pine needles, she saw a likely home for — well, for something with a very long Latin name. We literally did not see the same world."

David explores that line of thought (and many others) in a series of provocative essays in *Notes on a Shared Landscape: Making Sense of the American West*. He also offers this additional thought (adapted here from a passage in that book) about the way we process information. "In a well-designed *Illustrated Guide to Mushrooms*," he says, "those mushrooms would be illustrated in vivid detail, rendered sharply against a muted background, one that offered some hint of habitat without getting too specific about it. Implicit in such an illustration is a theory of how the mind works—namely, that clear images on drab backgrounds aid recognition. And they do. We make sense of the world (at least in part) by piecing together plausible pictures and plausible stories from an unceasing blizzard of memory and sensation.

"We do this in every time scale, from that of a lifetime (where the story is our life) down to the time-frame of

Notes on a Shared Landscape: Making Sense of the American West, by David Bayles.

11

ordinary vision (where the story is the changing scene we have before us). Five times a second or so, in common moments, we freeze-frame the most plausible reality we can from what's available. Five times a second an electrical wave washes across our brain and we paint the foreground, mute the background, and thereby see, hear, taste, smell, feel the breeze on our skin. Several times per heartbeat, over and over from birth to death, we each separate the specific from the general, the figure from the ground, and decide which shape is the mushroom (or the field mouse or the lost contact lens) and which is not. We fit together the pieces that we can, and set aside the rest. The process of *being* unfolds as an endlessly overlapping succession of most-plausible-pictures. We become who we are by virtue of the choices we make — consciously or otherwise — about which parts belong to the story, and which parts can be left out."

It seems an almost transcendental quality of the mind that we can even *know* we see the world differently from others — and more amazing yet that we can share our separate realities with one another. Having spent a lifetime developing one mental map of the world — our own — consider the conceptual leap needed to make that lateral shift into an entirely different framework. Nonetheless, we do it all the time. Embedded within the simple phrase, *"What if...?"* lay a plurality of worlds. If your world is built around artmaking, expertise consists of more than just facility in making your work; it also

Perhaps art succeeds precisely because it remains ambiguous enough to allow others with wildly different mental sets to invest themselves in it. Maybe this is why art seems so dissimilar from "fact".

consists of facility in being you. You are the mushroom hunter in your own particular forest. Every conversation, every piece of artwork, every sensation is like a walk with the mushroom hunter.

❧ ❧ ❧

A map is a theory. So is $E=mc^2$. And the Bible. And a work of art. Each of these conceptual tools (and many more) offers a different way to look at the world, a different way to grasp its meaning. The meaning of the world is elusive — it allows for many opposing (and yet, paradoxically, equally true) conceptual maps for discovering and exploring that meaning. This is most readily apparent with large subjects — subjects long intertwined with human history, sometimes with our very survival. The Landscape is just such a subject. Workers from very different disciplines, applying very different theories, have constructed mutually exclusive (but internally consistent) conceptual maps of the territory. Consider for instance the outwardly unrelated yet deeply complementary contributions of two such explorers of the Landscape: François Matthes and Morley Baer.

François Matthes is not exactly a household name. That's hardly surprising given that he spent his entire professional career — fifty-one years — as a geologist with the United States Geological Survey. For Matthes, however, the job was a perfect fit for the work he needed to do. Now you first have to understand that the USGS is a

very rare bird indeed: a government agency that actually does meaningful work, does it well, and does it without hoopla and periodic scandals. Perhaps it was that benign obscurity that freed Matthes to pretty much tailor his job to suit his passion: tracing the origin and evolution of Yosemite Valley and the surrounding Sierra Nevada.

And so he did. Working in an age before satellites and computers, Matthes did his fieldwork *in the field*, using tools no more elaborate than a notebook, a keen eye and a few simple mechanical instruments. It was painstaking work, patiently examining each minute aspect of the Sierra landscape for such meaning as it would yield, and deriving overall theories from the phenomena actually observed.

In a society where retiring as a millionaire by age thirty is considered a benchmark of success, embarking on a quest that spans decades — and culminates in an obscure document titled *USGS Professional Paper #160* — may appear quaintly old-fashioned. Yet the results from such an approach are cumulative; they carry their own rewards. All around him François Matthes found the marks of Time pressed upon the land. The glacial polish, the alluvial fans, the fault line escarpments — all spoke to him of an arrow of time moving inexorably forward, irreversibly molding the landscape through successive periods of upheaval and erosion. Imagine: with little more than careful observation and deductive reasoning, this one man was able to confidently describe events that

happened (quite literally) a million years ago a mile beneath a mountain range that today no longer even exists! As Matthes himself was heard to comment, the fullest appreciation of any landscape comes only when one is also alive to its *meaning*. Verily.

Morley Baer was likewise a passionate explorer of landscapes. An architectural photographer by trade, he spent his free time photographing the rugged coastline of northern California. Now the wonderful thing about photography (especially in its pre-digital form) is that it is intensely *experiential*. Simply put, to make a photograph you have to *be there*.

But where exactly *is* "there"? It's not a rhetorical question. Like everyone else, photographers are often all too unsure about what's really important. They're uncertain what they live for, and so they're unsure what they should photograph. Sadly, there's abundant evidence of this in every medium — the world is filled with inconclusive art. But while artists seem inordinately prone to bouts of uncertainty, really good artists also have strong internal compasses that send them dependably (if often intuitively) in the direction of those particular uncertainties that most attract or terrorize them.

For Morley Baer, that compass bearing took a setting early. He would often tell the story from his childhood of being taken by his grandmother every week to hear the neighborhood German-Jewish fiddlers play. To Morley, at age seven, they all sounded pretty much alike, but his

grandmother was emphatic in her judgments. Technique was not enough. In her book, the *good* fiddlers were those who played *"mit feeling!"* And she was right. The most distinctive quality of artmaking is the investment of the artist's own humanity in the finished piece. As Morley would later tell his own pupils (in his benignly acerbic way), "Your statements *will* be personal — whether you like it or not!"

When Baer composed a landscape on his camera's ground glass, he did not see Matthes' arrow of time, but rather an enduring and repeating cycle. He spoke of the California coast as a drama of ceaseless struggle — a struggle never settled by winners and losers (as we so often expect things to be resolved) but rather an interplay of great forces that affect each other without conquering. Where Matthes was a Classicist, searching for underlying structure, Baer was a Romantic, seeking the emotional core. (He once commented to me that he wondered just what those rocks were *doing* as they sat there facing the Western horizon.)

François Matthes and Morley Baer (and our mushroom hunter as well) each offer singular additions to *our* understanding of the world. Their efforts provide clear evidence of the way the creative process transcends any particular discipline. Creativity is not the sole province of artmaking. In fact creativity is not even about artmaking *per se* — it is about *seeing.* Seeing, for the mushroom hunter, was the natural reward of useful experience on the trail

of mushrooms. In that sense artmaking is more akin to finding mushrooms than to knowing about already-found mushrooms. Arm-chair explorers who know a lot about already-found mushrooms do not necessarily know anything at all about how to find them. Simply put, we become experienced by *having experiences.*

Bach didn't need to know the Church doctrine on Transubstantiation line and verse—he needed to know how to make music that soared.

Making Sense of Art

Hegel said that you must not think to understand
what art means until you can first
understand what philosophy says it means.
That was like Hegel.
It was, indeed, rather like philosophy.
— Lascelles Abercrombie

RT THEORIES ARE GOOD. Art theories are impressive. But hey, wait a minute — it's the *artists* who do the work! Most every artist I've known is far more comfortable grappling with the difficulty of making art than with the seeming futility of talking about it. The chances are, as Robert Henri phrased it, that if art has anything to say to you at all, it will say it to you *as art*. Why on earth would anyone want to look further?

Well, one fairly substantial reason is that while we absorb art through all our senses, we *think* about art in words. When it comes to making or experiencing art,

Robert Henri was author of *The Art Spirit.* First published in 1923, his book numbers among the handful of genuinely timeless writings about art.

For that matter, try analyzing *anything* without allowing words to enter your consciousness. Zen masters excepted, it can't be done.

Hegel's *Theory of Aesthetics* runs on for a thousand pages, and its text is notoriously opaque. Consider yourself forewarned.

words are optional — but when it comes to interpreting the meaning of that art, words are the universal drug of choice for our species. Call it human nature.

Given that conceptual bias, and given that art has been with us since the dawn of history, you'd think we would've long ago reached some universally accepted definition of just what art *is*. Seems reasonable, hasn't happened. Instead we've settled for a motley collection of often-competing views — everything from bare-bones dictionary entries to multi-volume philosophies. About the only thing these efforts share in common is that they're uniformly unconvincing, especially to artists themselves. Dictionaries may be perfect for winning Scrabble games, but they tell us nothing about what it means to *be* an artist. And all-encompassing theories, likewise, have proven virtually useless when it comes to helping anyone actually *make* art. All in all, it's hard to escape the feeling that somewhere along the line a disconnect occurred between the makers of art and those entrusted to explain it.

This much we do know: long before there were art departments or art critics or art historians or art museums, there was simply art. Period. All those efforts at classifying and cataloging and codifying art, at "discovering" and ranking and promoting artists — they all came after the fact. And in any case, there aren't enough pigeon-holes or spotlights to go around — art comes in too many flavors for that. We're moved to make art for reasons that are varied, complex and often intensely personal. Some art

has always come from the heart, and some from the head; some art draws on tradition, some on innovation; some art strengthens our beliefs, some questions those same beliefs; some art plays with our intellect, some plays with our emotions. The real boundaries of art are defined by the collective range of our minds, not by the collected works in anthologies.

For artists the more relevant question is not whether art can be defined, but whether it should be. After all, what good does it serve the artist to ask *What is Art?* Will it cause the paint to fall to the canvas any sooner? Will it make the finished piece turn out any better? Will it extend your artistic reach? The answers are problematic at best.

Artists often have good reason to avoid inquiring too closely into motive and purpose — especially while they're in the midst of working. Like the little cartoon critter who blithely runs out beyond the edge of the cliff without harm — until he looks down! — artists can be paralyzed by knowledge itself. When it comes to making art, our intuition is often light-years ahead of our intellect. Photographers are all too familiar with the experience of viewing the pictures they'd made a day earlier and finding themselves thinking, "Why on earth did I photograph *that*?" The reason, often enough, is that we sense the meaning of the world unconsciously and capture that meaning through our art — and then have to wait for our intellect to understand what we already knew. The common myth of the artist as prophet — heroic as it may be — is just a bit

off the mark. Better to view the artist as the messenger. The prophecy is in the artwork itself.

But while pre-philosophizing about your next art piece may be an invitation to triviality, and philosophizing about your in-progress work may cause paralysis, looking back over your past work almost always pays a useful dividend. An appreciation for your artistic roots adds richness and depth to your art; an appreciation for your contemporaries' art reveals facets of the world you share in common (and perhaps some you never even knew existed). Besides, the moment you achieve even a modicum of success you *will* be asked to explain your work, and in the course of preparing for that eventuality you may well learn something about your art — and yourself — along the way. *Where, then, does your vision of the world reside? What part of your art is drawn from history? What part is prophecy? What part is grounded in fact? What part takes wing in fantasy?* These are useful questions. Do you really want to leave it to outsiders and non-artists to make up your answers for you?

Many people, if asked why they make art, would disavow even having a choice in the matter. They'll tell you with complete sincerity that they never asked to become artists — they simply feel compelled to share the truths they've discovered (or the truths that found them). Simply put, they make art because they have to. In some quarters that need, all by itself, is considered the prime litmus test for whether one should take up artmaking in the first place. There's a celebrated passage in *Letters to*

a Young Poet in which Rainer Maria Rilke writes, "This above all — ask yourself in the stillest hour of the night: *must* I write? Delve into yourself for a deep answer. And if this should be affirmative, if you may meet this earnest question with a strong and simple '*I must*,' then build your life according to this necessity; your life even into its most indifferent and slightest hour must be a sign of this urge and a testimony to it."

Needless to say, Rilke was a hopeless romantic — in today's world he'd be hopelessly outnumbered by prag-matists, cynics and the generally bewildered. Art may be a high calling for some people, but many others leave no space on their mental map of the world for the ideal or the romantic, much less the ineffable or the sacred.

❦ ❦ ❦

But getting back to the question at hand: *What is Art?* It's a deceptively simple question, rather like asking just where a cloud ends and blue sky begins. The answer looks clear and distinct from a distance, but as you come closer the line between cloud and sky — between art and not-art — grows increasingly fuzzy. Surprisingly, however, that may be exactly what we should be looking for here: a fuzzy answer — a way to describe the intangible *flavor* of artmaking. And like other questions that yield only better or worse answers (rather than right or wrong answers), it helps to edge into this one slowly.

My own experiences convince me that art is drawn from life, and that any worthwhile theory of art will, by its

Letters To A Young Poet, by Rainer Maria Rilke, has inspired generations of beginning artists. The same can be said of Edward Weston's *Daybooks* in relation to young photographers.

very nature, honor whatever those life experiences reveal. (How could it be otherwise?) The practical value of this approach is that it leads to an appreciation for art that is inclusive rather than exclusive. Begin with the premise that every work *could* be art, asking only that each piece be judged on its own merits, and a whole new world of artistic possibilities opens before you. Respond to the pieces themselves first, and *any* theory you develop about art will flow naturally from your response. Moreover, this approach invites all of us—not just the professionals—to address some really useful questions about artmaking.

Suppose, then, you set out to illuminate the qualities that you—that's you *personally*—associate with a piece of art. What could you learn about the nature of art by simply responding to the piece itself, without invoking any pre-set theory about what it should be called? Simply put, what is it you respond to in someone's work that leads you to call it "art"?

Taking that approach, the first step toward developing your own theory of art is startlingly direct: *Look at the work.* Look at lots of work. Look at lots and *lots* of work displaying every possible form and purpose. And then ask yourself: *Does this piece* feel *like art?*

Just for starters, consider this sampler:

> *A sunset*
> *A Bierstadt painting of a sunset*
> *A robin's nest*
> *A Frank Lloyd Wright house*

A child's finger-paintings
Your own drawings
The Mona Lisa
Your neighbor's perfect rose garden

Better yet, fill the margins of this page with your own list of candidates—the more provocative the better. Whether any particular piece counts as art is your judgment alone. There are no wrong answers.

There are, however, lots of different answers. Consider the sunset, a seemingly easy call. Many of us would probably say that Bierstadt's painted sunset feels like art, but that an actual sunset doesn't. The difference seems clear enough: the natural sunset simply exists, while the painted sunset was made—isn't that why it's called art *making*? But then consider the fact that the next two items on that list—the bird's nest and the Frank Lloyd Wright house—are both artificial constructions (albeit one of them by a robin). If we dismiss the robin's effort as mere "nest-building", then by what rationale would Frank Lloyd Wright's efforts be accorded some privileged status as "architecture"? We could argue that birds merely operate on instinct while humans rely on conscious reasoning, but should that make any difference? After all, when artists engage their work they often disengage their intellect, relying on intuition alone to guide their actions. And with intuition itself only a half-step removed from instinct, one could even make a pretty good case for the

proposition that the most important parts of artmaking are those which demonstrate the *least* difference between people and animals.

If you felt your eyes glazing over as you read the preceding paragraph, rest assured you're not alone. In truth it may not even matter whether you respond more to intellectual, emotional or intuitive stimuli — the main thing is simply to avoid being paralyzed by the paradoxes and contradictions that pop up like *poltergeist* any good discussion of art. Perhaps the best any of us can do is simply to follow a conceptual pathway for as long as it yields helpful results, and when a point of diminishing returns is reached, change course. It is, after all, your art world — and you get to set the rules!

In this instance, after identifying several art-like pieces, a good follow-up strategy might be to stand back, survey your choices, and frame a question that addresses all of them at once. Like: *What traits do* all *art-like works share in common with one another?*

The answers are out there, but they won't be found by simply rounding up the usual suspects. Familiar qualities like form, style and genre vary wildly from one art piece to the next. And specific elements like proportion, balance, rhythm, harmony — the qualities that encompass our definition of beauty — are so universal they offer no way to differentiate between a sonata and a salt crystal. Now that is a strange discovery! After all, they're perfectly valid art terms, and they serve us well in a myriad of circumstances — so why don't they help us here?

Part of the problem is that those terms all describe art by looking at product rather than process. That provides a good handle for explaining how a finished piece was constructed, but a poor one for revealing why the art was created in the first place. The ability to compare, contrast, catalog and classify works of art is not the whole story. For artists it's not even the important part of the story.

As artists, our real-life experiences give us an understanding of artmaking that is neither intellectually evident nor emotionally accessible from the outside. Viewed from the inside — by those who actually make the art — it's self-evident that the elements of art that remain constant belong not to the art pieces, but to the art *making*. And that in turn reveals an entirely different set of values. When artists look at the qualities shared in common by all the wildly dissimilar efforts that have (over time) been recognized as art, they go by names like *sincerity, trust, passion, care*. Where else would you expect to find the sources of authenticity of both art and life?

The sincerity of the effort. The passion in its pursuit. The care in its execution. These terms rarely appear in college art texts or contemporary art magazines, yet whenever you look at the way artists actually work, these and similar qualities emerge.

But therein lies a quandary. Namely, if those qualities lie anywhere near the core of artmaking, then wouldn't *anyone* qualify (at least some of the time) as an artist? Wouldn't it mean that *any* work imbued with trust, sincerity and passion might qualify as art? And what exactly

Where does "art" reside? In the intent of the maker? In the piece itself? In the response of the viewer? In the space between?

would the objection be if the answer came up "yes"? — that it might mean sharing the artistic high ground with our neighbor and her perfect rose garden?

Ah yes, the rose garden — a perfect test case. Now be honest here: does anyone really believe that a landscaped garden is even remotely comparable to a fine landscape painting? (OK, four people do.) The prevailing wisdom, however, is that the artistic possibilities of gardens are inherently limited, offering (at most) faint echoes of qualities that only achieve their full voice in (ahem) Fine Art.

And indeed there are big differences between painting and gardening, but those differences have more to do with culture than art. From a purely artistic standpoint, both man-made landscapes and painted landscapes present us with transformations of nature. Gardens create content — *meaning* — by using physical space to define our aesthetic, emotional and social relationship with the land. Sometimes the effect is intimate, leading the visitor to a reflective or meditative state of mind (or toward spiritual high ground, as in the medieval gardens that sought to replicate the Biblical vision of paradise). Sometimes the effect is expansive, as large gardens evolve into parks and even larger preserves honor nature by *not* altering it (as in our National Parks). Sometimes a layer of social interaction is added into the mix, as in the Japanese ceremonial tea garden, or in Zen gardens aligned with meditation exercises. Sometimes *etc.* — the list of conceptual pathways is long and varied.

But most of the time none of the above apply. At least not here, today, in Western society. In the East the traditional raked sand garden and the Japanese art of flower arrangement (*ikebana*) remain highly valued as artforms in themselves. But in the West even the magnificent gardens at Giverny rank mainly as attractions on the tour bus circuit, while Monet's paintings of those same lily ponds rank as priceless art treasures.

And so, like many other genre that have been disenfranchised as serious artforms, gardens remain entirely capable of expressing larger truths—but rarely do. Most gardens today have more modest aims. And if my own backyard garden on Seabright Avenue is any indicator, the most prevalent role of the garden today is simply to provide its maker with a small oasis of peace and privacy —a refuge from an increasingly harsh world. There's certainly nothing wrong with inward-directed art—but it does suggest that when your neighbor creates that perfect rose garden and the highest *outside* recognition she can aspire to tops out as a ribbon at the local county fair, it says as much about our society as it does about art. Perhaps more.

ART
&
SOCIETY

*I will venture to conclude, however, that what
the arts were for — an embodiment and reinforcement
of socially shared significances –is what we crave
and are perishing for today.*
— Ellen Dissanayake

 N THE BEST OF WORLDS, artmaking would be
encouraged, its destination would be clear,
and society would cultivate the relationship
between artist & audience. And indeed, iso-
lated examples of just such a world can still be found,
though mostly in a few geographically remote cultures,
and a few artificially sheltered settings like the university.
Clearly, however, those worlds do not flourish widely
— and certainly not here, now, today, in our decidedly
unsheltered environment.

31

Artists today work in the face of some very large problems. These are the big ones:

ART plays no clear role in our culture.
ARTISTS have little direct contact with their audience.
ARTMAKING is indulged, but rarely rewarded.

Admittedly, that's painting the issue in broad dark brush strokes. Still, the fact remains: the moment artists venture beyond their studio door, they quickly discover — usually the hard way — that there's a big difference between pursuing a life in the arts, and doing something society more obviously values. Preparing for a life in the arts is not like studying to be a chemist or a truck driver or a computer programmer. Among other things, those people have a place waiting for them in the workforce. Artmaking, however, seems to be work whose value is conceded, but not rewarded. Becoming an artist means creating your own path and in all likelihood going it alone. It means relying almost entirely on yourself in a world that's more or less indifferent to all that you do. Art may be recognized as a noble profession, but it rarely gets mistaken for a useful occupation. That may explain why so many artists build their own studios: no one *else* is likely to build one for them. "*Help Wanted — Fine Artist*" is not a large column in the newspaper classifieds.

It absolutely does not follow from that, however, that the life of the artist was ever any easier in times' past. Life in early times was frighteningly provincial, isolated, difficult,

For that matter, there's a big difference between a life in the arts and life in the *art world* – but more about that later...

perilous and depressingly *short* compared to what we've come to expect today. But on the flip side, every individual was also part of a larger community where people had extended families, knew their neighbors, shared common beliefs, and out of necessity worked together for the common good — and often the sheer survival — of their community. The life of the early artist wasn't any easier — but in many ways it was more rewarding.

For most of human history, art was an integral part of daily life. Most historical artwork played a role in society or religion or both. Among the earliest art objects yet discovered (or more accurately, re-discovered) in North America is a tiny but magnificent ivory sea lion (or seal) carved by an Alaskan Native twelve thousand years ago. Holding that artifact in your hands, you can't help but feel the interconnection of art, religion, solitude, survival by hunting — all that and more reflected in the care and dedication invested in that piece by its maker. That carving is not only good art, it is also art that flowed from the center of its culture.

In another time and culture closer to our own, Johann Sebastian Bach composed new church music for each Sunday Mass — and he was just one composer among hundreds who held similar jobs. Think about that: there was a time (and not all that long ago) when artists were employed to make new art every week — art that addressed the deepest issues of life and death and spirituality. We have nothing like that today – and it makes you wonder:

how would art and artists be received today if we made work that spoke *for* the community rather than *to* the community?

There's pretty good evidence that Bach himself understood that to make work that mattered meant addressing art at every level — from the purely technical to the completely profound—*simultaneously.* He once composed a set of training pieces whose purpose, he said, was "to glorify God, to edify my neighbor, and to develop a cantabile style of playing in both hands".

Some version of Bach's three-tiered work order might be a worthwhile guide for artists working today. Today we've become a society without community. Today most artmaking is not part of something larger than itself. It certainly isn't within the art world, where the embattled but still dominant postmodernist view holds that artists are not even the authors of their own work — that there is no such thing as an "original" piece of art, but rather that we make art by taking things out of their original context (*i.e.* deconstruct them) and reassemble them in a new context. This idea that "the subject of art is art" may be a stimulating intellectual proposition within the art world, but it also goes a long way toward explaining why most non-artists find zero connection between their own life and that same art. How deeply *can* art matter if the only fitting description of its meaning and purpose is "art for art's sake"? Perhaps all of us — artists and otherwise — would benefit from Bach's self-imposed discipline

that each of us should work to glorify God, educate our neighbors, and expand our technical abilities. Maybe *that's* how you open the door to creating art that matters in a culture that otherwise displays little interest in issues of substance.

ꙮ ꙮ ꙮ

There's a pervasive myth, shared by artists and non-artists alike, that art is a product of genius, madness or serendipity. Wrong. Art is not the chance offspring of some cosmic (or genetic) roll of the dice. Art is mostly a product of hard work. When you look back on the results of a lifetime of artmaking, even the role that talent played is insignificant. Living life productively, however, is very significant. One of the less-advertised truths about artmaking is that it's more important to be productive than to be creative. If you're productive, your creativity will take care of itself. If you are not productive — well, if you're not productive, then how exactly is it you intend to be creative?

And for that matter, what exactly does it mean to be creative? "Creativity" has become a hot-button topic of late — college courses teach it, magazine stories claim it wards off Alzheimer's, bookstores display entire shelves of inspirational books on the topic. Personally, I remain stodgily uninspired by all the uplifting rhetoric. I can never quite figure out exactly how learning to *Paint Naked!* will result in the production of meaningful new work. I have

It's been estimated that during his career as a composer, Bach wrote an average of twenty pages of music per day, most of it used once and then discarded.

a theory that books like *The Twelve Step Program to Freeing Your Inner Artist* bear less similarity to artmaking than to diet plans and exercise videos. You can test this theory yourself on any late-night infomercial: simply replace phrases like "You can have a great new body in thirty days!" with "You can make great new art in thirty days!". The similarities in the sales pitch are striking. Nonetheless, as a humble public service (and for a percentage of the gross) I'm offering the next one hundred readers a one-time opportunity to pre-order these upcoming blockbusters: *Men Who Make Art & The Women Who Leave Them; The South Beach Palette;* and *How I Made A Million Dollars Through Leveraged Creativity.* Wow! Operators are standing by. Thank you. We now return you to the real world, already in progress.

I think it was David Bayles who first drew a clear and convincing distinction between "creativity" and "the creative process". He noted that as the term is commonly employed today, "creativity" describes only one very specific quality in art—namely the quality of being "new" or "different" or generally innovative. While many critics and viewers deem "creativity" a high virtue, it may be neither an essential nor even a very common attribute among artists themselves. Some good artists fit the "creativity" mold very nicely, many other equally good artists do not. Bach was conventional, Picasso wasn't. It didn't seem to bother them.

On the other hand, having a working command of the creative *process* — that is, all those elements that lead to

the making of art—is truly essential. The creative process unfolds as you find the essential tools in your toolkit. It means finding your subjects (not someone else's) and finding your materials (not someone else's) and most of all it means finding a way to live your life so that you can engage again and again the things you care about the most. Conversely, failure to find a viable working process turns would-be artists into ex-artists long before they get anywhere near making their best work. Standing in your studio, surrounded by your tools, the distinction between creativity and the creative process is as simple as the distinction between being innovative and being productive. Countless artists have made good art without being particularly innovative, but almost no one makes *any* art — good or otherwise — without first learning to be productive.

Most of the individual art pieces you produce along the way, however, will never even be seen by the outside world—and perhaps surprisingly, that's exactly the way things are meant to be. For viewers and critics and dealers and collectors, the important thing is how good the work is (or sometimes how saleable it is, or how good the story is that goes along with the work, or whatever). That's fine. That's their concern. But to you — the maker — the important thing is whether a given piece helps show you the way down the road to the next piece. Looking back over a pile of early pieces, you come to realize that it's the ninety-nine percent you never show others that laid the groundwork for the one percent that soar.

Good work doesn't mean anything unless it's also carrying you down the road. If you develop productive working patterns and learn from the work itself along the way, you will always be on the path toward making the best work you can. If you don't do that, then a handful of good pieces you make early on won't amount to a hill of beans.

So what (if anything) does all this mean for you? What it means is that to make your own place in the world, you'll probably need to create a life in which working on your art becomes a natural part of your everyday life. It means consciously constructing your life in a way that would have come naturally to the ivory seal carver (who, by the way, probably drew no distinction at all between life and art). There's no predicting how any individual life will play out, but there is a guiding principle for reaching the best of *possible* outcomes: stay at work on the things that are really important to you, and you will reach your potential as an artist.

What it all comes down to is that art is not made by a special breed of people, but by ordinary people who have dedicated a piece of their lives to special work. Doing special work can become a routine part of your life — in fact, it almost *has* to if you're actually going to get any work done. Artists are not weird people who work only when inspiration strikes. (Well, OK, most of them aren't.) Artists are regular people who work all the time, and lead real lives all the time as well. Annie Dillard nailed it

when she wrote, "How we spend our days is, of course, how we spend our lives". Artists are not exempt from that truism. Fix breakfast, cut the grass, do the laundry, write a poem: *That* is the real life of an artist.

Today, in a culture where nothing is sacred, we may have to find ways to honor things that really matter in daily life. At the day-to-day level, artmaking is a process of trying to do something you care about really well. Indeed, many of the problems that go with artmaking are the same problems that go with trying to do *anything* really well. Ordinary people make art when they make extraordinary concerns a part of their daily life.

On Christmas Eve at the local arts center in Volcano, Hawaii (a tiny community far removed from, well, just about anything), a half-dozen local musicians came together to perform Bach's *Brandenburg* concerto. Word of the upcoming performance had spread through the community, and most everyone in the neighborhood showed up — whole families, in fact, replete with children, a few amiable dogs and lots of homemade cookies and potluck offerings to share. Now as you might suspect, there aren't many cellos and oboes in Volcano. Actually, there aren't any. And so Bach's famous score was altered to accommodate a ukulele, a slack-key guitar, a slide trombone, two violins and a clarinet. It became a shared event involving the entire surrounding community — and old J.S. himself

The Annie Dillard quote is from her book *The Writing Life*. Annie isn't a highly prolific writer, but every book she's completed – beginning with her Pulitzer Prize winning first book, *Pilgrim at Tinker Creek* – comes about as close to perfection as you can get with the written word.

would have been proud. Their performance, for all its informality and improvisation, radiated the spirit of art-making as fully as any recital at the Lincoln Center.

It's a worthy example, but the sad truth is that such stories of community participation in the arts today are few and far between. We live in a society where difficult things are increasingly left to experts and specialists. So people take vacations to New York City to see the great art, buy CD's to hear the great performances, subscribe (occasionally) to PBS to watch Masterpiece Theatre—and at a glance it all seems entirely positive, even virtuous. Yet that all-too-easy access to perfection comes at a steep price: the loss of individual participation in the arts. In an era where the media confer fame early, instantly (and often fleetingly) the opportunity for the measured development of one's art is the first casualty. And beyond that, how many artists have the resilience to see their still-developing work placed in direct competition with the legends of their field? Not many. The net result is that we have become a society composed almost entirely of audience.

This is unhealthy, both individually and collectively. Artists need to feel they have the support of the community in their artmaking efforts—if not for what they have already achieved, then for the potential they represent. Artmaking is too important to reduce to a spectator sport. We can't afford to leave artmaking to a chosen few—the few are not enough. One more genius or superstar would

not do as much to make this world a better place as would thousands and thousands of people across the country quietly making art on a daily basis. The need for more art in the community is not nearly so great as the need for more *artists* in the community. Every neighborhood should support a musician or two, a painter or two, a writer or two.

Personally, I take it as an article of faith that when you make art, you are making the world a better place. Everything that happens afterwards—whether to you or to your art or to society—flows directly from that initial act. Your job is to make the art. That's what artists *do*.

Even if all the really important art *is* made by a few geniuses, the sort of world proposed here would at least bring to light more geniuses than we see now—and create a more informed and responsive audience along the way.

THE EDUCATION
OF THE ARTIST

*The best thing about the future is that
it comes only one day at a time.*
— Abraham Lincoln

O THERE YOU ARE, ALMOST A BEGINNER and still a million brush strokes away from the paintings you want to make. You shine your desk light on the sketches you've taped to the kitchen wall, compare them in your mind to the great works you've seen in museums — and gravely doubt there's *any* way that your work will *ever* make it from Point A to Point B. Indeed you may wonder what magical qualities you'd need to even begin such a journey. Genius? Boundless courage? Maybe a rich patron? Actually, naiveté and *chutzpah* are more likely candidates. But it's also possible, just possible, that those who have gone before you may have something to say about all this — and that with their help you may not need to re-invent the wheel in order to begin the journey.

43

Your role in this, if not easy, is at least clear: learn the things you need to learn in order to do the work you need to do. If you need to paint a hundred paintings before you're satisfied with one, then your job is to paint the hundredth painting. Artists need to take satisfaction in all those small steps, because that's where almost all the progress gets made (even if the outside public only sees and cheers the rare and wildly improbable leaps). Truth is, caring about the work you do is the single best indicator that others will also care about it. The same goes for learning. If you think mastering the things you care about is difficult, try mastering the things you *don't* care about. A friend of mine realized this recently when she stumbled upon her old college transcript—complete with grades for *entire courses* that had left no visible trace upon her memory. Consciously or otherwise, we each self-select the path we need to take.

That path, however, has a curious way of drawing us into areas far removed from our day-to-day patterns—and though we don't always appreciate it at the time, those seeming digressions can pay big rewards on down the line. The broader value of studying History or Physics or Spanish or Art is that every discipline teaches a different approach to problem-solving, a different way to measure what's important—sometimes, in fact, a different sense of what *is* important.

Key works in every field draw upon the wisdom of seemingly unrelated disciplines. Charles Eames learned

Sometimes it's the detours you take that provide the learning you need.
– Tim Kelly

44

how to mold plywood under heat and pressure while working at a naval shipyard, and later folded that knowledge into the design of his world-famous Eames chair. Physicist Howard Edgerton invented the high-speed strobe light, and then spent a good part of his career using it to reveal the unexpected beauty of fleeting events like the arc of a golfer's swing or the splash from a single drop of water. Ansel Adams combined the discipline from his early training as a musician with his knowledge of photographic chemistry to create the Zone System for controlling the tonal scale of photographs. There was even a time late in World War II when a lone American military researcher saved the city of Kyoto from destruction by convincing military planners not to target it for saturation fire-bombing. Why? Because he had once visited Kyoto's gardens and shrines — and was moved to protect their *beauty*.

Real-world examples are wonderful things, and for good reason: precisely because they *are* real, they cut right through virtual worlds of theory and abstraction. They also raise large questions about how the process of education actually works. After all, if there's no predicting which particular piece of knowledge or experience will later prove essential, we're faced with the disconcerting possibility that *everything* matters. And if that knowledge or experience could come from anywhere, the clear implication is that teachers are *everywhere*. That line of reasoning may appear extreme, yet after field-testing those

Adams took the science of photography and made it understandable and meaningful to the artist.
— Al Weber

The researcher's name was Langdon Warner.

45

exact premises for about a half-century now, I've reached an inescapable conclusion: *Yes*. Everything *does* matter. Teachers *are* everywhere.

Where, then, do you start? Well, fortunately, you already have. Conceptually speaking, that ever-changing instant of reality we call the present is merely a point in time weaving its way into a universe of potential we call the future. Every decision you make alters that pathway. One undeniable consequence of this is that everything you learned or experienced in the past has somehow delivered you, at this moment, to *this sentence*. You may be traveling a path that will closely parallel mine for years to come, or one that fleetingly intersects at right angles—but right here, right now, we share this common ground.

Even if we cannot control what we perceive, we can control how we spend our time—and the control of time is the gate to perception. You can only have the perceptions (and hence the experiences) that you put yourself on a course to intercept. In fair measure, the person you become is the natural outcome of the experiences you have. Your job is to watch where you're going (!) and hopefully have the foresight and freedom to make a few mid-course corrections along the way. Learning is cumulative, and one of the truly wonderful things about artmaking is that it gives you permission—at any given moment, in any given art piece—to access anything you need, from any source you find, to express any idea you wish, in any form your heart desires. You can't ask for more freedom than that!

❦ ❦ ❦

An education in the arts opens with the premise that some things *do* matter more than others. Or more precisely: matter more to you. Picture yourself, say, standing in a bookstore, face to face with sixty thousand choices. Obviously you could spend several lifetimes methodically reading your way down the shelves. And just as obviously, you won't. It's not just a question of time, it's a question of purpose. If there were no purpose behind the choices you make, then you wouldn't actually be making choices — you'd simply be rolling the dice. So what you actually do is spend an hour looking for one book that clearly resonates with (or pushes against) your view of the world.

We hardly need to "decide" to scan for knowledge — it's already hard-wired into us. Our species seems to harbor a singular need to understand why things are the way they are — a need to grasp their underlying nature. There must be a hundred disciplines — everything from poetry to particle physics — just waiting to enrich our understanding of the world. Each in its own way contributes an essential piece to the puzzle. The scientist creates experiments whose readouts give form to an outer reality; the artist creates artworks that give form to an inner reality. Both constitute an imagination of the possible. The difference is where we search for the possibilities, and in that regard some encounters will always prove more consequential than others. Almost every artist I've met can recount — often in passionate detail — some particular experience or some

special person who first opened them to the potential of art in their life. Each of us has a story to tell about the path that brought us to this point. *Where did you learn the things that really matter to you? Where was that critical fork in the road that directed you to this point? Who have been your real teachers?*

It's easy to assume that our understanding of the world is a product of the education we receive — in other words, that we all begin as students. And at least on paper, the classroom environment seems perfectly suited to keeping focused on that goal. But just as we sense the troubling gulf that stands between law and justice, or between spirituality and organized religion, it's hard to ignore the disconnect that has arisen between learning and schooling.

For better or worse, we've created an educational system that only works on any large scale when the knowledge being offered is first pre-packaged into teachable gradable transferable and preferably marketable semester-length courses — and in recent years, structured as well to satisfy the current political demand for quantifiable *proof* that learning has occurred.

At the California community college where I teach, the system for satisfying these requirements takes the lofty (if grammatically challenged) title of "Student Learning Outcomes". It works like this (take a deep breath): First, package the course into tightly focused assignments

I include this passage for the benefit of my students and fellow teachers. If you live instead in the Real World and are unaffected by such academic nonsense, consider yourself lucky.

and subdivide each assignment into explicitly defined items-to-be-learned. Then list each item-to-be-learned in its own box on a "performance rubric" (*aka* spreadsheet) accompanied by a detailed written statement defining exactly what the student must do to be awarded some allotted number of points for that item. When a project is completed, award separate points for each item-to-be-learned, tabulate subtotals for the various boxes, weight, combine, average and convert them into a final letter grade and — *TaDa!* — you have a "Learning Outcome!" certifying exactly how much each student has learned. Wow. I feel smarter already.

Of course instructors aren't actually *forbidden* to help their students to see the world with greater clarity, or to find their own voice, or to to make art that matters — but it does become an interesting challenge. Good teaching still trumps bureaucracy every day of the week — it's just that nowadays you have to be careful not to get caught at it!

Not surprisingly, formula-based approaches work better in some fields than others. Placed within tight constraints, the universe of ideas that *can* be explored implodes dramatically. When students are rewarded for finding answers that lay (quite literally) inside the box, it hardly encourages them to think outside the box. Subtly but pervasively, like the force of gravity, formula-based systems trivialize art, compacting large ideas into cookie-cutter McNuggets of knowledge. They're not called Standardized Tests for nothing.

Hmmm. What happens when a student's response is *better* than any answer the instructor envisioned?

Even if grades could reliably cleave true from false, that's still only one of many purposes they serve — and one of the more trivial purposes at that. And in any case, students *always* know who among their classmates deserve the most credit. They know who's been making amazing headway (even though their work is still unpolished); they know who's been valiantly hanging in there (even though all hell's breaking loose in their personal life); they know who's coasting along without improving (even though their flawless work, cashing in on easy-come talent or past training, meets all the Learning Outcomes requirements).

The whole dreary issue of grading pretty well sums up the uneasy fit between art and academics, a condition that art students — a rather paranoid lot even in the best of times — all too readily attribute to a vast right-wing conspiracy to keep art in its place. (Well, OK, there's that too.) In his extraordinary novel *Zen & The Art of Motorcycle Maintenance*, Robert Pirsig exposed the dark underside of the grading process with deadly accuracy: "A bad instructor can go through an entire quarter leaving absolutely nothing memorable in the minds of his students, curve out the scores on an irrelevant test, and leave the impression that some have learned and others have not. But if grades are removed the class is forced to wonder each day what it's really learning. The questions, *What's being taught? What's the goal? How do the lectures and assignments accomplish the goal?* become ominous. The removal of grades exposes a huge and frightening vacuum."

Zen & the Art of Motorcycle Maintenance, by Robert Pirsig. Of all the books I own, none has more passages underlined and notes pencilled in the margins than this one. It is an absolute treasure-trove of ideas.

50

In academia it's considered a virtue to frame questions that yield clear, concise and demonstrably correct answers – answers that remain unchanged no matter who responds to the question. But equally, there exists another entire universe of questions in which the answer *always* changes as each new person engages the question. You can measure to a clear, concise and objective certainty the color of the sky above your head — *but what is the color of the sky inside your mind?* For Maxfield Parrish the correct answer was cerulean blue; for Albert Ryder it was midnight black; for Beethoven it was F major. Questions that introduce shades of meaning and degrees of certainty and value judgments into the equation engage entire fields of human endeavor that fit poorly (if at all) within the prevailing educational framework. Like the arts, for instance. Making headway in the arts is a process of navigation without numbers. How do you measure what is Good? What happens when there are many correct answers to a given question? And what happens when some of those answers are profound, others superficial? Or when some are intellectually abstract, others searingly personal?

Those are not — pardon the pun — academic questions. If a roomful of students all arrived at the identical (and demonstrably correct) answer to a math question, it would be exemplary. But if those same students answered an artistic question by producing a roomful of identical paintings, something would be terribly wrong. Indeed, if the only things that counted were the things you *could* count, then Haydn would clobber Beethoven 106-9 in

51

the symphony playoffs, and the Museum of Modern Art would hang street banners declaring *Whoever Paints the Biggest Picture Wins.*

Still, just looking around you, there's no denying that this educational approach has had a truly remarkable track record. In a very real sense it made the twentieth century possible—or more precisely, it made the *complexity* of the twentieth century possible. And as we become ever more dependent on specialized technology here in the new century, we also become ever more dependent on the system that supports it. When knowledge is highly compartmentalized and questions are framed to generate verifiable and repeatable solutions, certain things become possible. Exhibit A: The Space Shuttle. Unless two million electronic circuits and mechanical parts function *exactly so*, the whole thing just sits there like a hundred-ton paperweight. (Or worse, a firecracker.)

But even as some things become possible, other possibilities are lost. Wisdom does not reside in facts alone —experiential, intuitive and moral judgments on how knowledge should be used lie near the core of our definition of humanity. As history suggests, getting a rocket off the ground is only half the equation.

> *"Once the rockets are up,*
> *Who cares where they come down?*
> *That's not my department"*
> *Says Werner von Braun*
> —attributed by mathematician/songwriter Tom Lehrer
> to the inventor of the German V-2 rocket

Hiring thirty thousand artists to design a rocket sounds like a poor idea. But then again, hiring thirty thousand rocket scientists to paint a picture probably wouldn't work either.

Unfortunately we're given little preparation for balancing the far side of that equation. As T.S. Eliot framed the issue, "Where is the wisdom we have lost in knowledge? Where is the knowledge we have lost in information?"

❦ ❦ ❦

It's hard to resist a slow-moving target. But even if we all agreed that the current arts educational system is a setup for failure, what then? That system, flawed or otherwise, has roots that stretch back a century or more and will likely be with us for decades to come. The school years may be the perfect time to take on large problems, but do you really want to pencil in *Change Basic Premise of Educational System*" at the top of your To Do List?

It is, of course, entirely possible to master your craft without any formal education in the arts at all. After all, a degree in art doesn't automatically make you an artist any more than lacking a degree precludes you from becoming an artist. In his classic book *The Shape of Content*, Ben Shahn offered his prescription for an ideal education in the arts. In what is arguably the most passionate passage in that book — a full page and a half delivered entirely in italics — Shahn's appeal to the student can be summed up in two words: *Do Everything!* And well you should.

Despite the obvious pitfalls, however, clearly there often *are* good — sometimes even compelling — reasons for embracing a formal education in the arts. Beyond the obvious benefit of imparting craft, school offers an environment that supports and values and encourages the work

The Shape of Content, by Ben Shahn. First published in 1957 and continuously in print ever since, it's one of the best books ever written about the purpose and practice of art.

you're trying to do. It provides a safe harbor to begin building a network of friends and community that will serve as the life blood to your continued growth as an artist after you leave school. Your teachers provide introductions to ideas, to people, to processes — simply put, they provide you with the opportunity to make discoveries.

And for what it's worth, the university is also the only source for obtaining a graduate degree in Art. Now that sounds impressive! But wait a minute: why would you need one? Certainly not in order to be an artist. After all, how often do you hear about art being exhibited or published (much less garnering rave reviews) because its maker has an MFA? Not often. If you doubt that an art degree has real value, however, all that really proves is that you're not planning on a career in teaching. Viewed dispassionately, an MFA is a glorified union card. To be considered for a teaching job it's rock-bottom essential; in most any other setting it's just another sheet of paper. So if you can survive without seeing your name inscribed on *faux* sheepskin, your opportunities for an education in the arts expand far beyond the university to include everything from apprenticeship to workshops to simply plunking yourself down where the action is.

❧ ❧ ❧

I did time in art school.
— anon. ex-student

I once started to make a list of people I've known over the years who had tangibly affected my artistic growth, and quickly found I could cite about fifty such benefactors

in the length of time it took to write down their names. I suspect it's the same for you. People we admire, people we hardly notice, people we rebel against — they all play a role in making us who we are. And while those roles are sometimes wildly different, most fit into a few familiar frameworks.

Friends, especially our close friends, typically become part of our lives for long periods of time, often for years, sometimes for decades. The corollary is that they can exert a huge influence on our day-to-day decisions and activities, sometimes with life-changing consequences — even though long-term planning rarely plays a role at the time we make those choices.

Teachers, by contrast, play a brief but much more focused role. At the surface level, of course, they help us master the tools of our trade. But more importantly, they help us define our own long-term goals — and then give us a nudge in the right direction. The downside is that our contact with a teacher is usually brief — at workshops only a week or two, in universities rarely more than a year or two. Once that link is broken — long before we've reached our goal, and often before we're even sure enough of ourselves to set out on our own — they're no longer around to guide us.

There is also, however, a third source — rarer, but sometimes more essential — that incorporates the best qualities of both. By consensus (but without demanding an exact definition) we call such people mentors.

And oh, did I mention *lovers*?
Read Edward Weston's *Daybooks*.
Any questions?

Mentors combine the long-term contact typical of good friendships with the wisdom and guidance we associate with good teachers. In many ways mentoring echoes the holistic qualities of a traditional apprenticeship, one in which master and student work together and learning becomes a mutual experience. I suspect that, on average, a mentor is often older (hence a source of wisdom) and working in the same field (hence a source of expertise). But in truth, they can appear from anywhere—being a fellow artist is not a prerequisite. The bond between mentor and novice is easily sensed but defies easy definition. If you'll settle for a fuzzy definition, it's that they share an intangible rapport that makes time spent working together satisfying and worthwhile to each.

What any particular artist gains from their mentor is, by the very nature of the experience, highly individual. In my own life I've known maybe three or four individuals I would count as mentors. Their names for the most part would mean nothing to an outsider. However, one of them — photographer Ansel Adams — is well-known in the larger world, and using him as an example makes it a bit easier to illuminate both sides of the mentoring equation.

I first met Ansel when I enrolled as a young student in his Yosemite Photography Workshop. And just to give you a capsule overview, I returned to those same workshops in succeeding years, first as an assistant and later as an instructor, and some years after that I moved to Carmel to

serve as Ansel's full-time assistant at his home/studio. In some overlapping fashion he was my teacher, employer, colleague and friend for the last fifteen years of his life (and the first fifteen years of my artistic life).

I think what I gained most from Ansel over those years was a sense for what it means to have a truly clear vision of the world. Ansel saw the world revealed in the large-scale features and intimate details of the natural wilderness. Without that belief system to inform and direct his artmaking, using a large format camera and devising an elaborate system for controlling exposure and development would have been a pointless academic exercise.

Ansel was single-minded as an artist, but he was broad-minded and encouraging as a teacher — and thankfully so, given that I was just beginning to find my own voice and could've been completely blown away by a single crushing critique.

Most of my learning, however, occurred by osmosis, watching the way Ansel adapted camera/lens/film in the field to record the scene itself, and later as he manipulated the print in the darkroom, converting the optical reality captured by the lens into the deeper aesthetic reality that had led him to expose the film in the first place. Of course I learned gobs of hard-core technique as well, but most of those particulars needed to be un-learned later on as photographic technology changed. What remained with me, however, was an underlying love of craft and a belief that quality *counts*.

And over the long run what I came to value most were the intangibles I absorbed simply by standing near someone who had found something important that he needed to say through his art, had molded his technique to match that vision, and — most of all — demonstrated the strength of will it takes to stay focused on reaching that goal. It isn't the equipment or tonal range or recent auction price or even the subject matter that I relate to when I look at Ansel's art — it's the sincerity and passion and care and trust he embedded into the making of that art.

❧ ❧ ❧

There was a time when apprenticeships provided virtually the only entrée into the arts, and even today working with a master remains an admirable pathway to perfecting one's art. Unfortunately there's one large obstacle to implementing that idea: there aren't enough masters to go around.

But if landing a decade-long one-on-one apprenticeship with a top artist in your field sounds unlikely, attending a week-long workshop with that same person is often a surprisingly attainable goal. It turns out that top artists in every art medium — people who would never settle into teaching semester-length university classes — are often genuinely attracted to leading a concentrated workshop designed around sharing what they know best. The secret, both inside and outside academia, is to ask around and find out who the really good teachers are — and always

go with the best you can find. Finding the perfect course title is secondary. If you find a good teacher you're bound to learn something worthwhile, but if you find even the perfect course topic and get stuck with a drudge, it's worse than not taking the course at all — you'll merely end up bored or discouraged about the very thing that had excited you enough to take the plunge in the first place.

Workshops offer aspiring artists arguably the best — and absolutely the most concentrated — of all educational possibilities. A really good workshop generates a level of intensity that's virtually impossible to achieve in the classroom. That potential is embedded in their very structure: working together closely sixteen hours a day for three days virtually guarantees a richer and more varied experience than sitting in a classroom three hours a week for sixteen weeks.

In a traditional school setting, intensity is diluted by short and widely-separated class meetings, continuity is lost as everyone scatters to the winds at the end of each class period, and ideas dissipate before they ever fully develop.

Workshops, however, typically engage participants during *all* hours of the day. Moreover, every student figures out sooner or later that the really important discoveries don't even happen during the formal morning or afternoon sessions — they happen in the spaces between sessions, out in the field or over lunch or coffee, or late in the evening when everyone's sharing sketches spread out all

over the floor and arguing about the future of the world. These intense and often intimate encounters at the edges of the main event bring another revelation — that finding your friends is every bit as important to your future as learning your craft.

Sadly (or at least ironically) the gap between workshop and university instruction is slowly widening. Many art teachers currently nearing retirement age earned their reputation the old-fashioned way: they made art. But with the "terminal degree" (such an instructive term!) now the universal prerequisite to teaching at the college level, art departments are increasingly populated with faculty who essentially never left the nest, leaping directly from MFA Program to Tenure Track without ever muddying their feet in the real world. The academic climate is changing, and with it the very nature of the art that emerges from that new environment. The contemporary art gracing the walls of galleries today is largely the product of this new academic order.

❧ ❧ ❧

Despite any surface appearance of formal structure, a good education in the arts is still mostly improvisational theatre. It's a delicate dance played out every day in classroom, field and studio, as teacher and student take central roles in this timeless interplay between potential and experience. It's also a high-stakes dance — there are lives at stake here, and education changes those lives. Simply put,

teaching has consequences. As a First Principle, teachers would do well to heed the counsel of Hippocrates: *First, Do No Harm*.

Every now and then some particular exchange throws all those elements into sharp relief. Awhile back at a photography workshop one of my students was a bright young woman who had always been, for as long as she could remember, excruciatingly shy in the presence of strangers. This was plainly evident from her portfolio: Jennifer made elegant images of trees, rocks, water, details, abstractions, even animals — but never included even a single human figure within the frame. It was a startling artistic omission, coming as it did from someone who was entirely unself-conscious and gregarious among her friends.

It would've been easy enough at that point to hand Jennifer an individualized assignment to "make portraits of strangers" — but to what good end? Being told to do something we've always avoided simply short-circuits the learning process — it neither encourages nor enlightens. In fact it's usually downright unpleasant. By my accounting, good teaching is more a process of raising the next question (or next hundred questions) a student needs to confront in order to make headway in their work. The answers pretty well take care of themselves — after all, when it comes to resolving the really important issues in your life, no one else has the answers you need anyway. With that in mind, I posed a few questions for Jennifer to mull over:

What's the easiest subject for you to photograph?

What's the emotionally riskiest subject you'd dare approach?

What do you have a passion to photograph !?!

What's the single greatest obstacle standing between you and the art you need to make?

Well, a few days later we took a fieldtrip to an ocean-side state park, and Jennifer brought along — apparently as a prop for a picture she had in mind — a larger-than-lifesize toy plastic seagull. Once there, everyone quickly scattered to the winds and I lost track of Jennifer for an hour or so — until suddenly she came running up and announced breathlessly, "I just took two rolls of portraits of strangers!" This, mind you, from someone who had not taken ten pictures of strangers — cumulatively — in her entire life.

Her strategy was deceptively simple (and charmingly deceptive): she stood on the pathway leading into the picnic area, and as each new group of tourists approached she held up her slightly absurd toy and said, "I'd really like to get a picture of my pet seagull — would you hold him for me while I take his picture?" And verily, the next morning, there on her proof sheets (that's why they're called *proof* sheets) were portraits of seventy-two complete strangers — every one of them holding that same dumb plastic seagull!

Buckminster Fuller once commented that there's nothing about a caterpillar that tells you it's going to become a

butterfly. It's a great line, but it misses the mark — at least as far as artistic development is concerned. Every good teacher bears witness to such metamorphoses. Watching young artists at work — their energy sparkling with the intensity of a summer lightning storm — is an exercise in humility. You soon realize that your real purpose as a teacher may simply be as a catalyst, offering a few provocative ideas here, clearing the way past a few technical hurdles there, and eventually just pointing the way to the far horizon.

After that, well, all you can do is stand back and watch, hoping they can hold it all together long enough to convert their seemingly limitless potential into accomplishment. Over time it is life's enduring patterns and rhythms that sustain us. This holds as true in education as in any other facet of life. Every student, sooner or later, will wear a teacher's hat. And every teacher, periodically, will return as a student. The cycle is common and recurring, with teacher & student trading roles many times over the course of a lifetime. It's a universal truth: giving back what we receive gives life meaning. Ask any parent.

Surviving Graduation

*I began my education at a very early age
– in fact, right after I left college.*
—Winston Churchill

HE ART SCHOOL YEARS are likely to be the only time in your life when all the important people in your life encourage you in your artmaking, and all the resources you need to make that art are readily accessible. Free as a bird (and with harsher realities yet to make their appearance), it's small wonder that during those brief exhilarating years so many people dream of building a life in the arts. It's simply easier to picture yourself as an artist — and in fact it *is* easier to lead an artist's life! — at about age twenty than at any other time, before or after. At twenty, laying claim to the title *ARTIST* seems entirely natural. At twenty, building a future with art as its centerpiece seems entirely

plausible. People on the outside may not fully understand the forces that drive you, but they do understand that those forces are leading you to make art. Moreover, the outside world tacitly agrees that you *should* be making art — after all, that's what people do in art school.

Cynics, of course, are quick to point out the obvious: that art school is an utterly artificial environment. But then again, where exactly do they expect to find a *natural* environment? The rest of the world is no less artificial — it's just one hell of a lot less receptive to art! Art school is a small island of acceptance in a vast sea of disinterest.

Ironically, the learning experience that art schools offer is possible largely *because* they're different from the outside world. In art school you're surrounded on a daily basis by people who believe — *fervently*! — that artmaking is the highest and most important form of human endeavor. You've given yourself permission (for a time, anyway) to trade the workaday world for a more secluded world shared with your fellow travelers. You're in a space where ideas are valued, experimentation encouraged, excellence rewarded — where you can test new ideas, acquire new skills, compare in-progress work, and focus body and spirit on work that truly matters to you. You produce work in the clear certainty that it will generate feedback. Feedback from teachers and fellow students comes to seem a natural part of artmaking: you expect it, it's all around you — and in fact you're going to get it whether you want it or not!

For a huge number of non-art majors, art classes provides the *only* opportunity (at least until retirement kicks in a half-century later) to pour even a few months of concentrated energy into pursuing matters of the heart.

No similar mechanism grows naturally in the outside world. After graduation, feedback is hard to get – except perhaps in the form of rejection.

Not surprisingly, one hallmark of such an environment is sheer productivity. It's a whole lot easier to be productive when you're immersed in a culture that values artistic production — where you're encouraged to be productive, expected to be productive, rewarded for being productive.

Most students enter their first art class armed with one percent experience and ninety-nine percent potential. And from there, fortunately, sheer enthusiasm is often all it takes to sustain them long enough to conquer the basics of their craft and see their first ideas materialize into *real things*. The long-term outcome of a formal education in the arts is *direction* — the chance to zero-in on a particular art medium and to master the materials and technique within that medium. All those repetitions, control tests, rough drafts, rehearsals — they may not number among the most romantic features of artmaking, but they do number among the most essential. They make finished art possible! By valuing long-term plans above short-term checkbook accountability, the school years underwrite the sheer amount of time such efforts require.

As you might suspect, a myriad of pitfalls line the way as well. It's not uncommon for a student to be completely overwhelmed, right at the outset, by the expertise or personality of a particular teacher. What is perhaps surprising is that it's often an entirely reasonable response. Chances are we respond to certain teachers because we *already* share their vision. We're drawn to them because

they're expressing the very things we would say through our own work — if only we already knew how.

But it's a double-edged sword. Even the teachers you most admire may lead you, however unintentionally, to trade your vision for theirs. Sooner or later every artist needs to claim their artistic independence, and that means placing a healthy aesthetic distance between their own work and that of their most important teachers. Artists who fail to make that break may well stay in the game anyway, but usually as niche players, building entire careers out of beautifully crafted variants of their mentor's art. Shining in the reflected glory of the Master, they're generally remembered as *a follower of...* Call it immortality by proximity.

Still, confronting a challenge that you can (quite literally) attach a name to is a fairly straightforward process. The far trickier issue is coping with (or sometimes even recognizing) the whole diverse sea of influences at work in the classroom. Simply put, structure skews process, and process skews results. Assignments, deadlines, competition for grades, the pressure to be "different"— all these forces (and more) exert a powerful influence on the style and content of art made in the classroom. The net result is that in school it's easy to make lots of art, but difficult to make *your own* art.

Making headway in your art means pushing ahead continually, day by day, on both conceptual and technical fronts. For veteran artists, concept & technique eventually

become so closely interwoven that it's hard to separate one from the other — they unfold simultaneously. For beginning artists the advance is more cyclical, like putting one foot in front the other. There are times when you find an idea or subject that attracts you, but lack the technical ability to express it. So you throw your energy into advancing your technical skills, and sooner or later (if all goes well) you're on a roll and churning out piles of good new work. And just as surely there will be other times when a productive run reaches a point of diminishing returns. The work begins to feel redundant or predictable. You begin to feel the pressure to move on, to explore a new idea or technique or medium. It's the familiar "Been there, done that" reflex, and it's hardly unique to artmaking.

It is, however, unique to humankind. It just might turn out that we're hard-wired to look for questions rather than answers — that answers are merely the delivery system for getting us to the next question. Ours is the only species that, upon finding a "right answer", turns away from it to search for another question worth asking. That trait may not explain why we make art, but it goes a long way toward explaining why we're *driven* to make art: we're conceptual hunters.

In his classic book *The Lives of a Cell*, Lewis Thomas explored this and similarly intriguing issues. His short essays are a gem-like blend of personal and scientific observation.

Sooner or later (and despite our best efforts at denial) classroom assignments become just another exercise in work-avoidance. At some point you're more qualified to

teach a course than to enroll in it. Lesson for the day: leaving school is just as important as entering school. When classroom life slips into the past, themes and elements you folded into your work to emulate teachers or satisfy assignments slowly lose their relevance. Leaving school allows the voices of teachers and peers to stop echoing in your head. Leaving school allows you to listen to your own voice. Leaving school opens the path to the future.

As generations of artists would attest, however, that transition is neither easy nor painless, and the results often remain murky or contradictory for years afterward. Looking back on her first three years in art school, one of my soon-to-graduate students could see clearly the things she had lost — but was not yet sure about the things she had found:

The writer is Jane Waterbury, who has since graduated and gone on to a career in graphic design

I look back at the work I was doing before the Art Institute, and it was innocent and free. I feel like the work I'm doing now is polluted, corrupt — and it's more difficult to make! I think this probably has two causes: (1) seeing the Art World and the ideas contained in it; and (2) leaving my element.

Before coming here I lived in a small town in the middle of the desert. The desert and things and places that were in it were part of my work; an abandoned house was my studio. When I had an urge to make art, I would. The desert was my element — and now I'm out of it and haven't quite adjusted. The corruption was caused by the pressure to make art in a certain way: art with "content".

I have been changed by this place; I can't go back to making pictures with the same innocence I used to have. I think my art was moving toward content before I came here, just not as fast.

And, I might add, not necessarily toward the same content. The underlying question is: What *is* yours? When, exactly, does your heritage take root? Every artist I've known has struggled — sometimes briefly, sometimes for their entire life — with striking the balance between internal and external direction, between native and foreign influences. That issue can be notoriously difficult to resolve, but what it suggests is that beyond mastering our craft, the most important goal for each of us is also the most personal: finding our own voice.

We recognize that someone has found their voice when their distinctive spiritual or emotional core becomes an inseparable part of their art. Reaching that threshold means letting the concerns and influences of others fall away, so that your own voice is heard clearly. It takes a whole lot of dedication and conviction and hard work and talent and luck to make that happen — but most of all it takes time. For that reason alone, finding your voice is a quest that rarely reaches its goal during the school years.

Even were they to accomplish nothing else, however, the school years do buy you the time to begin that journey. In art school you don't have to ration your time between art and life because your art *is* your life. In art school your artmaking energy is rarely depleted because you're virtually inundated with stimulating input on a daily basis. By comparison the outside world is remarkably dull. And therein lies the peril: your easy access to tools & teachers & ideas & input may last four months or four years, but it all ends when you leave school.

In art school you may never experience input depriva-
tion, and thus may be ill-prepared to cope with it when
graduation strikes. The first time you have no deadlines,
no presentations to look forward to, no critique sessions
looming, no daily feedback and no new ideas swirling all
around you—the first time that happens you may feel like
you've stepped into an artistic vacuum. Period. Then what?
With graduation you leave a world that embraces what
you do, and enter a world that's indifferent to what you
do. This is a serious transition. Graduating is one thing—
surviving graduation is another thing entirely!

❦ ❦ ❦

After graduation, jobs and relationships impose their
own regimen, often pushing artmaking far from center
stage. After graduation, those who make art are rarely
full-time artists. Most of us (this author included) make
most of our art during evenings and weekends.

After graduation, you alone are responsible for—well,
for just about *everything* that school so readily provided
until you left the nest. It's no easy task, but there are tan-
gible steps you can take, and the results are cumulative.
Here are the keys to the post-academic universe:

DAILY PRACTICE. Continuity is the key to productivity
—at the outset, in fact, it's the key to keeping you in the
game long enough to even *become* productive. The very
first step toward making art on a continuing basis is to
carve out a predictable, repeatable time *every day* (!) when

outside distractions can't touch you. You may need to create a separate workspace for yourself as well. And where your artmaking requires prep time, let those preparations become the warm-up exercises — perhaps even a simple ritual — that ease you gracefully and naturally into the day's work.

A PLACE IN YOUR LIFE. Artmaking takes on a life of its own when it nests comfortably among the other activities of your daily life. Having a daily practice helps that process along. It helps if the other people in your life to understand this as well, and respect your need to practice art on a routine basis — frequently, and without interruption. Chances are you're going to need to educate them on this a bit.

RAMP-UP TIME. The time you set aside for artmaking is precious. When that time arrives you want to be able to walk into your studio and begin meaningful work *just like that* — without first plowing through an obstacle course of unrelated chores, digressions and work-avoidance ploys. Walk in and start working, *period.* Like dieting, it's largely a matter of self-discipline. Turn off the computer, silence the phone, hide your ToDo List, lock random children in the closet, whatever. Just do it.

MATERIALS YOU LOVE. You can always tell when someone genuinely loves his job, and you can always tell when an artist genuinely loves the materials she works with. When hand and soul work together, it shines through in

the results. And really, how could it be otherwise? Why, for instance, would you even want to become a writer if you didn't enjoy dancing with words? How would you ever expect to reach the top rank of dancers if you didn't take satisfaction in pushing your body to its limits? The physical act of making art is a conversation between you and your materials. It's a simple equation: make work that talks back to you, and then listen to what it says.

SETTING THE BAR. Artists love to describe themselves as being process-oriented rather than goal-driven. Sounds good — but if it's true it may also explain why so few artists complete even one additional body of finished work after they've left school. One of the less advertised features of human nature is that our drive to excel rarely exceeds our capacity to procrastinate. Just like everybody else, artists rarely get down to work without a little nudge from the outside. Viewed that way, committing yourself to a varied diet of small-scale projects — filling a family album, assembling a ten-print portfolio, entering a juried competition — may provide exactly the energy boost needed to get you off the starting blocks. Consider this: a self-imposed deadline to complete even just one new art piece each month would result, by the end of a year, in enough finished art for a small solo show.

FELLOW TRAVELLERS. The one irreplaceable and incomparable asset to building a life in the arts is the presence of kindred spirits and fellow travelers in your life. The

74

closing chapter of this book focuses on precisely the value of these bonds within the artistic community.

❧ ❧ ❧

Your mastery of craft is directly proportional to the sheer number of hours you throw into the effort, but your vision unfolds in concert with your total life experience—in other words, slowly, and only across extended periods of time. School affords gobs of concentrated time to develop your craft, but measured against a lifetime that's still only the briefest leading edge of the time required for your vision to mature. It's not like wisdom and perspective magically appear in the fourth grade or twelfth grade or even in college. How many people really know themselves at age eighteen? Did you? I certainly didn't!

As John Gardner observed, "Mastery is not something that strikes in an instant, like a thunderbolt, but a gathering power that moves steadily through time, like weather." Artistic maturity emerges slowly and progressively as the natural harvest of repeated cycles of increasing self-acceptance and self-awareness.

Artmaking is not a Royal Road. It's a slow but cumulative process, changing the world one artwork at a time—and along the way (the gods willing) having the experiences of your generation and influencing the experiences of the next. Over the long run it's the relationship of your art to the entire culture that determines its value. In the deepest sense, the relationship of your art to the culture *is* its value.

AUDIENCE

Hell is a half-filled auditorium.
— Robert Frost

 YOUNG ARTIST approached the Zen Master and with the forgivable brashness of youth asked straight-away, "Tell me, Master, how can I paint a perfect picture?"

The Master smiled.

"It is very simple," he replied. "First, lead a perfect life. Then, by its very nature, every picture you paint will also be perfect."

Ah so. Well, if you have achieved that state of grace, you're probably not reading this book. But if leading a perfect life is unlikely, it's still entirely possible to lead an *interesting* life — and I would maintain (as my modest contribution to art theory) that if you lead an interesting life, you're on track to make interesting art. Your job is to put yourself on an intercept path with interesting experiences.

And if you'll indulge here me for a paragraph or two, I can tell you just how I finally came to embrace that concept myself. As a beginning photographer I attended a photography workshop taught by Ansel Adams. That also made Ansel my first and only photography teacher, with the not-surprising result that I swallowed his artistic vision hook, line and sinker. Large format black-and-white landscapes, in fact, quickly became my *definition* of art photography. It took me years to realize that I don't lead a sharply-focused fine-grained life — that far more often life had been whooshing right past me while I was trying to set up my tripod.

That truth finally hit home when I decided to put together an album of family pictures to give my son for his eighteenth birthday — a hundred images, with Jon as a designated audience of one. The final album was indeed quite poignant, but in the process of gathering the pictures I made a disconcerting discovery. In searching through literally thousands of negatives I'd made over those years, I found that for every photograph I had of Jon, I'd made about a hundred pictures of sand dunes, weathered barns, geometric abstractions, majestic landscapes and other certifiable "Fine Art" subjects. Yet compared to my snapshots of Jon — images I wouldn't trade away for *anything* — my so-called "serious" pictures seemed singularly artificial and, well, insignificant.

That one revelation entirely changed the way I approached my artmaking. Ever since, I've worked hard to

Viewed in retrospect, I guess Jon's birthday album actually had an audience of *two*.

keep the line between my life and my art as short and straight and clear as possible. Now when I go out to make photographs, I don't spend one second looking for "significant images." And I intentionally avoid razor-sharp lenses that seduce one into thinking that realism is the same as reality. Instead, I hang a little plastic camera around my neck, carry it pretty much everywhere I go, and photograph whatever crosses my path.

I'm not sure whether my approach is rare or commonplace. I've known other artists who take dead aim on artmaking and then drag *life* along for the ride. Likewise, I suspect that all of us, artists and otherwise, devote such care and love to *some* particular activity — anything from fly fishing to stamp collecting — that the activity itself becomes a surrogate for artmaking. And some rare individuals (not me, alas) engage the world so deeply, and see its every moment with such clarity, that their life *is* their art.

All those approaches share at least one piece of common artistic ground: namely, that the art would never get made in the first place if it didn't matter personally to its maker. Otherwise, why bother? — it would just be so much aimless arm-flailing. What may be less obvious, however, is that making art that matters *only* to its maker is a knife-edged proposition. Artists cross the line from self-expression to self-indulgence at their own peril. In his later years, Ezra Pound increasingly wrote verse that was meaningful — or even intelligible — only to himself. And as he abandoned his audience, they abandoned him.

Your Zen Moment of (Photographic) Truth: The single best indicator of whether you'll make a photograph in any given circumstance is *whether you have your camera with you.*

Liking or disliking the subject of your art ranks low on the scale of importance – the main thing is to be *interested* in the material.

Today his later *cantos* are read by an audience of twelve graduate students. I think Bruce Miller had the best take on runaway egocentrism: "To those who believe that art consists of displaying 'what's inside them' without regard to the comprehension of an audience, or say that the audience must learn to appreciate and understand what they've done, I say *'Nan troc ongh plooth'*."

That's not to deny self-expression as a perfectly valid end in itself. Personally I'm a believer in both the virtue of artmaking *per se*, and in its good effect upon the well being of the artist. Many artists (myself included) would tell you that the best part of being an artist is *making* the art, and that we'd likely continuing doing exactly that even if there were no audience out there at all. When audience is added into the equation, the whole process quickly becomes more complex and often more troublesome.

Complex, troublesome and *essential*, to be exact. It may not matter in absolute terms whether you play to an audience of one, or an audience of everyone, but until your art reaches out and touches *someone*, it's like the proverbial tree falling in an empty forest. Over the long run, art without audience is incomplete. The meaning of your art may be embedded in the artwork itself, but its purpose arises from its relationship with audience. Simply put, the things that matter to you — the stories you have to tell — exist to be shared. So questions arise: *Who is the real audience for your art? Where would you hope to find your art ten years from now?* In art galleries? On magazine covers?

In your family scrapbook? Engraved in the memories of people you've never met? If you hope to make art that matters, the first question to ask is: *Matters to whom?* To God? To the world? To the *Art* World? To your friends? To yourself alone?

❦ ❦ ❦

Those who do take that first scary step of exposing their work to the larger world soon discover that even with interesting stories to tell, there's no assurance the resulting art will resonate with anyone else. Not to put too fine a point on it, but audiences can be shallow, fickle, opinionated, stingy and generally *wrong*. Or as playwright Ashley Brilliant pronounced dourly after one completely disastrous opening night, "My play was a complete success. The audience was a failure."

Of course audiences might say the same of artists.

Even in the best of circumstances, however, artist and audience are rarely a perfect match for one another. The world is filled with artists who showed their work *once* and then vowed, "Never again!" Many continue to create wondrous new worlds, but then—appointing themselves both judge and jury, artist and audience—they stash them all in cardboard boxes in the hall closet. Make art for an audience of one, and that's exactly what you get.

One strategy to counter to that fate is to focus on smaller worlds—worlds selectively populated with an audience more responsive, more sympathetic and more likely to share the values central to the artist's vision. Making art

for a specific audience has a far greater chance of generating a response than art cast to the winds in hopes that *someone* will respond to it. Living in (and producing for) some small corner of the world is the daily regimen of the overwhelming majority of artists at work today. Often the resulting work is never even intended for outsiders, but is instead directed only toward the particular audience that embraces its premise and purpose.

Thus artists who (for instance) care about the loss of wilderness to urban development can focus their art upon endangered landscapes, all with the plausible expectation of being understood by the world of kindred spirits who share those concerns. The same holds true for those who care about magical light on desert cliffs or about the AIDS epidemic in Africa or about the translucency of certain porcelain glazes. When something is important, *art appears*, even among those who would never call themselves artists. Japanese-Americans held in Relocation Camps during World War II made paper flower wreathes to honor the dead because no actual flowers grew in their barren desert camp. Today, when art plays little role in defining and reinforcing the overall values of society, sometimes the best we can do is focus our art upon some special piece of that world that lies close to our heart.

That gulf between artist and audience hardly existed in earlier times, when all art was local art. Mozart wrote his *2nd Horn Concerto* for his local cheese vendor, who happened to also be the best horn player in Salzburg.

Julia Margaret Cameron produced arguably the best photographic portraits in the history of the medium through the simple ploy of inviting her husband's friends to pose for her. On another scale entirely, the great cathedrals of Europe employed generations of artisans in their construction — and when completed served as the spiritual anchor and physical center of the communities that grew up around them.

There is, to be fair, a blunt counter to the romanticism of the preceding observation. Glory to God notwithstanding, the medieval Church was the Halliburton of its time, and cathedral building was subject to the same panoply of expense, exploitation, excess and corruption that remain a staple of large undertakings by the state to this day. That's just to concede that both the best and the worst aspects of human nature are always in play — sometimes in embarrassing proximity.

But if human nature remains a constant, our lives still play out against an ever-changing backdrop. Where once people gathered in real communities to experience original art, today people lead insular lives and experience virtual art. Audiences have become demographic abstractions, and artworks virtual sounds and images stored on disks. We talk about original art, but rarely see it. You may well have a clear mental image of Michelangelo's painting in the Sistine Chapel, but have you ever *been there*? Today, the history of art is the history of art that gets reproduced, and while artists want to believe that art gets published

Contracts for cathedral construction went to church favorites. Out-of-town artisans already known for their work were hired – sound familiar? – or competitions were held where a single juror (a bishop, perhaps) made the decision. Artisans' careers were made or lost on such decisions. Does anyone remember who came in third in the design competition for the last set of Baptistry doors in Florence?

– Tim Kelly

because it's good, non-artists often assume the art is good *because* it's been published. It's sobering to realize that people outside the art world — which is, statistically speaking, almost everyone — typically grant more status to art they see reproduced in a magazine than to original art they see hanging in someone's home.

❧ ❧ ❧

Most artists — even demonstrably great artists — spend years, even decades, seeking validation of their art. In 1927 a young Ansel Adams made one of his most famous photographs: *Monolith: The Face of Half Dome*. Or more accurately, he made a photograph that several of his friends thought was very nice. The first publication of *Monolith* wasn't much to write home about. It appeared as a gritty halftone in a newsletter of the local chapter of the Sierra Club, credited to "A.Adams, Outing Club Photographer." A decade later the same image resurfaced in a brochure for a Yosemite concessionaire, and a couple of decades after that began appearing in coffee-table art books. Finally, a half-century after its first appearance, *Monolith* appeared in a *Time* magazine cover story about Adams accompanied by the headline, "Ansel Adams: GOD'S ART DIRECTOR."

Of course the future always appears inevitable fifty years after it's already happened. It's easy for us to imagine (now) that Adams could clearly see his destiny (then). Veteran artists make art that seems so natural, so self-assured and mature that it's hard for the rest of us

to imagine that they too were once struggling beginners. We may be entirely unaware of the help they got along the way from discerning friends or teachers or fellow artists. We may discount the importance of a spouse or an inheritance or sheer good luck in freeing them to pursue their dreams. And if the artist endured many dark hours along the way, we're encouraged to view it as a healthy (perhaps even necessary) artistic rite of passage. Wrong. Troubles may dog the artist's every footstep, but that's not what will make the art matter. Art matters when you say something essential about things you truly care about.

What we really learn from Adams' long odyssey is that recognition can be a fickle and unpredictable reward — one that may as easily precede, accompany, or arrive only long after the making of the art itself. Sometimes, indeed, decades or even centuries later. Bach's music lay forgotten for two centuries. The plain photographs of Atget and the utterly fantastical renderings of A.G. Rizzoli waited decades to even be recognized as art. Countless other works stand in the wings like children of a lesser god, still red-tagged as hobby, craft, commercial art, folk art, student art, whatever.

As a maker of handcolored photographs for many years, I'm painfully aware of the illogical boundaries that sometimes exist even within accepted genre. Before about 1975 art photography was universally considered to mean black-and-white photography, even though various color processes had existed since the early 1900's.

Hand-colored photographs fared ever worse; despite a history that stretched back to the earliest daguerreotypes, it was only in the final twenty-odd years of silver-based photography that this artform received even a glimmer of acknowledgment from within the art world. *What changed? Was it always art? Did it just* become *art? And who decides these things anyway?*

The fact that museums and art history books are peppered with re-discovered art offers grudging support to the contrarian view that art actually has a *better* chance of surviving if it's initially undervalued. Call it the Theory of Benign Neglect: work that doesn't "fit" gets ignored and forgotten and buried in some dusty attic — in other words, it gets unintentionally preserved simply because no one bothers to throw it away. Then, in different times, an audience with different sensibilities rediscovers the work and sees it in an entirely new light.

All art is subject to this extended and sometimes wildly erratic settling-out process. It just comes with the territory. And despite the concerted efforts of historians, critics and anyone else with a vested interest, no single person — not even the artist — can control the long-term response of history.

It's both sobering and freeing to know that over the long term, the fate of your may work be largely determined by an audience that has not yet even been born. Over time, the art you make will be filtered through layer upon layer of audience, and ultimately it is the art itself that will be

Napoleon was unimpressed with such intellectual nuances. His take-no-prisoners verdict was that fame is fleeting — but obscurity is *forever*!

History sweeps transparently through the time-span of any single life.

judged. So if you want the inside track on predicting an artist's place in history, look at the art itself. Better yet, be the one who makes that art! Audience is important, but the work is primary. My favorite declaration of that basic truth comes from author James Lee Burke. Recalling lessons he learned during his early days as a not-yet-published writer (and then had to re-learn all over again during a no-new-hardcover-for-thirteen-years dry spell), Burke's belief and strategy is that "you write a day at a time and let God be the measure of its worth; you let the score take care of itself; and most important, you never lose faith in your vision. God might choose fools and people who glow with neurosis for his partners in creation — but he doesn't make mistakes." Amen.

FROM MONET
TO MONEY

*Why don't we spend less money on advertising
and just make better airplanes?*
— Bill Boeing [1918]

UILDING AN AUDIENCE is a long-term proposition, and for artists the first order of business is staying in the game long enough for their work to even get noticed. The most direct strategy to that end is to simply make art. Make only art! Pursue no other goal! The clear virtue of this take-no-prisoners approach is that it places artmaking directly at the center of one's life. The clear drawback is that it usually means subsisting for long periods on sparse returns. Remember, we're talking here about the same strategy that gave rise to the romantic stereotype of the starving artist. So while it's clearly the prevailing choice among the student population, it can be a depressing lifestyle to sustain over time — eating day-old pizza and sharing an

apartment with six roommates tends to get old real fast after graduation.

Still, one way or another artists need to find a way to keep working at their art while waiting for their ship to come in. Strategies abound, but they pretty much fall into two categories. The first school of thought is to take a job as far removed from artmaking as possible. My favorite nominee in this category is Checkout Clerk At Safeway — steady hours, union wages, paid vacations, health care, and you don't carry the job home with you at the end of the day. The operative theory here is that by separating your day job from your passion, you avoid influences that might otherwise corrupt or trivialize your artistic vision. The peril, of course, is that you'll become as mind-numbingly dull as your job description, develop a lifestyle dependent on a steady paycheck, and eventually — as your last creative act — convert your easel into an ivy trellis. Anticipating that fate suggests a small amendment to the preceding strategy: find yourself an *interesting & stimulating* job far removed from your art!

The opposing strategy is to take a job in the nearest commercial application of your art. And why not? After all, the commercial world always values your skills (if not your passion) and will actually *pay* you to hone those skills and maybe even acquire new ones. It's no secret that visual artists pervade the advertising and graphic arts field, musicians ply the wedding reception circuit, novelists write technical manuals (or porn…) and so on. This can be a make-or-break issue in mediums where the

Selling your talent doesn't necessarily mean selling out. Bach wrote his Saint Matthews Passion as part of a job application for church organist.

sheer cost of tools or materials place artists in danger of being priced out of their chosen medium. The same holds true in the performing arts, where staying at the top of one's game demands that skills be practiced daily, often for hours.

Yet either from sibling rivalry or simply because their territories blur and overlap, fine art and commercial art have often had a rather prickly relationship (to put it mildly). The sparring usually pivots around whether work made for hire has any moral, spiritual or personal weight behind it. Or any content at all, for that matter. But while this issue still occasionally generates heated debate among artists, the public has long since dismissed any moral distinction between "fine" art and "commercial" art as being quaintly outdated.

And they may well be right. With the commercial world attracting many of the best and the brightest into its fold, some of the best contemporary art — and artists — *do* emerge from such fields as advertising and design. The best workers in any medium always transcend the constraints and stereotypes of their field. Today the fashion photographs of Richard Avedon and celebrity photographs of Annie Leibovitz have become templates for portraiture as art. Today the original Eames molded-plywood chair and the first Macintosh computer reside in the Museum of Modern Art. In a museum exhibit entitled "For Love or Money", artists were invited to display two pieces of their art: one that they had made to satisfy their muse (so to speak), and one they had produced on commercial

assignment. Visitors to the exhibit were handed a very neutral questionnaire that asked them simply to list their favorites. When the results were tabulated, viewers' preferences split evenly between the fine art entries and their commercial art counterparts.

This public attitude (or lack of attitude) has led to a curious case of role reversal, for as commercial art increasingly takes on the trappings of fine art, traditional fine art is increasingly marketed for its investment potential. At the low end there's The Franklin Mint and Thomas Kinkade. At the high end, art dealers create their own mini-monopolies by securing exclusive representation of high-profile artists, and then market their work via in-house exhibits, limited editions, programmed price-rises, spin-off book promotions and the like. Rather than declaring that art has value because it is important, they proclaim that art is important because it's valuable. (Well, *expensive*, actually.) All those faintly morbid trappings of the upscale art world — the crisp white overmats, the stark gallery walls, the grossly overpriced eight-page "catalog", the ice queen receptionist with some not-quite-identifiable accent — they all serve more to assure viewers that they are in the presence of something important than to protect that something against fading or fingerprints. Art magazines reinforce that message by linking trends in the art world to international auction prices, while at those very same auctions it's an open secret that dealers bid anonymously on their own artists' works in order to bolster those artists' reputations (not to mention justifying

"It's mainstream art, not art you have to *look at* to try to understand".
 — *A fan's defense of Kinkade's paintings*

and sustaining their gallery prices). Somehow the word *incestuous* comes to mind, yet from a business standpoint it all makes perfect sense. As Roger Lipsey dryly reminds us in *An Art of Our Own*, art dealers are in business to make money, not to make history.

The trick, of course, is to get artists themselves to buy into the idea that acceptance is a product of marketing, not message. Consider this genuine advertisement for a high-end (and high-priced) NYC art symposium:

An Art of Our Own, by Roger Lipsey. A truly intelligent book about many facets of art, including a wonderfully incisive critique of art in the marketplace.

BUILD A CAREER IN FINE ART!

Our panelists are important dealers and curators who will show examples of work by artists who have successfully caught their attention.

Apparently the gambit works. The director of one well-established West Coast gallery confided to me that fully three-quarters of her gallery's sales were accounted for by exactly two categories of art: 1) Masterworks by famous — well, OK, *dead* — artists; and 2) one particular artist's limited edition color lithograph of *really cute* little white boats. So there you have it, a ready-made recipe for success: Be dead, or paint little white boats.

All this makes you wonder at what point the quest for getting art shown begins to work against making art worth showing. That's the downside of playing the game by others' rules. At the least it leads toward making art that doesn't matter to yourself; at worst it denies you

your own value system. And beyond the damage artists do themselves in the race to become recognized, there's the damage they may inflict on those close to them. Deb Zeitman, a screenwriter who grew up as part of Hollywood culture, offered a singularly clear insight on the race for stardom: "I don't admire achievement as I once did. I'm starting to admire 'good' people as much or more than 'talented' people. I look at superstars and super-talents now and find myself thinking, 'Who was abandoned or neglected so that they could achieve their success?'"

Still, if the only goal were to attain quick visibility in the art world, the formula (at least on paper) is absurdly simple: devote ten percent of your effort to artmaking, and ninety percent to marketing and self-promotion. But it's a gambit that works (when it does work) only as long as you keep sprinting down the fame & fortune treadmill—pause for an instant and it's a straight drop into oblivion. But even though cultivated fame has little substance behind it, that hardly slows the stampede. In our media-dominated culture it's an open question whether fame is the result of accomplishment, or whether fame — all by itself — *is* the accomplishment. Today you can be famous for being famous. Ask Paris Hilton.

❦ ❦ ❦

Today audiences have easy access to art, but little access to artists. And conversely, a basic problem facing artists is their lack of direct contact with their audience. In the

art world today the line of communication runs between artist and dealer, and between dealer and audience — but direct communication between artist and audience is negligible. The perverse result is that neither artist *nor* audience decides what art will be widely seen. Today that decision belongs to the art world — and it smiles upon only a tiny slice of the spectrum. The most you can say is that while the art world may not be fair or balanced or comprehensive or even tasteful at conferring validation, it at least offers some validation to some artists.

This is not a concern, of course, if your art just happens to fit into a favored niche. Consider Cindy Sherman, a genuinely talented artist whose work matters both to herself and to the art world. The resulting fit between this artist, her artwork, and the art world is seamless and perfect. But to what good end? In a situation all too typical of the arts, the handful of people who know all about her art are also the only people who know *anything* about her art.

So it may be working out for Cindy Sherman, but we all sense that something has gone terribly wrong. What has gone wrong is that most of the art celebrated within the art world simply doesn't matter to anyone outside the art world. What that really tells us is that unless your art engages issues that other people care about, it isn't going to matter to them — and in the long run probably won't matter to you either.

Yet despite the flaws and shortcomings of the system, most artists probably wouldn't continue making art unless

they felt it had at least a fighting chance of being seen or heard or performed. The need for validation is basic, and it becomes an obvious gambit to seek that validation from the art establishment itself—a near-fatal attraction whose unmistakable symptom is the proverbial pilgrimage to New York City in search of upscale gallery representation.

This is not a journey for the faint of heart. We have a winner-take-all approach when it comes to conferring fame and fortune in the arts. Ours is a culture where virtually all the money and support goes to one percent of the artists, leaving the other ninety-nine percent of us to figure out how to lead a life that somehow allows room for our own artmaking. Call it a Super Bowl mentality: #1 gets invited to Disneyland (or MOMA); #2 qualifies for foodstamps. There's a monstrous gap between a few ultra-famous artists (however talented and deserving they may be) and the world of working artists whose names you never hear. The blunt truth is that only a handful of artists are anointed as New Talent each year, so if you approach artmaking like some giant King-of-the-Mountain competition, it virtually guarantees that you'll join a million others at the bottom of the pyramid.

❧ ❧ ❧

It's somehow reassuring to imagine that as artists we each forge a path uniquely suited to carrying our art to the larger world. Phrased that way, the trailblazing metaphor does have a certain heroic ring to it. Actually making the

journey, however, is a rather grittier proposition—especially when months roll by and the only check you're getting is a reality check. Winston Churchill must have smiled as he embedded that hidden truth in his airy quip that "success is the ability to leap from one failure to another without losing your enthusiasm". Verily, perseverance is a valuable trait in the art world.

My own so-called career has taken a long slow traverse across the arts, from architecture to design to photography to teaching to writing (and hopefully integrating a few lessons from each as I move on to the next). After graduation I worked straight nine-to-five jobs for about a dozen years. Then I jumped off the treadmill — and surprisingly it didn't make all that much difference, at least financially. I never had enough money when I was working full-time, and I don't have enough money now. But what has changed is that I have a *lot* more free time. I can put everything down and walk out the door on a moment's notice whenever life beckons. By my accounting, freedom beats security hands-down.

So nowadays I make photographs that find their way onto gallery walls or refrigerator doors, write books at the rate of about one per decade (and run a small publishing company that has—surprise!—graciously accepted *all* of them for publication), organize occasional workshops or lectures, and at any given moment generally have a few more projects circling out there like airplanes in a holding pattern waiting for clearance to come in for a landing.

Simply put, I lead a life of economic levitation. I've learned to trust in the law of averages: namely, that some check or another *will* arrive in my mailbox "soon" (even though a scan of my calendar reveals no clue as to how I'll avoid joining the ranks of the homeless in short order). Perhaps the real test for a life in the arts is not whether you can survive on a cycle of feast & famine, but whether you can live with the uncertainty.

Often, I suspect, it's only in retrospect (sometimes years after the fact) that artists can see clearly how much they already *have* accomplished. On a day-to-day basis, for instance, writing has got to be the most monumentally unproductive job imaginable. It took David Bayles & me eight years to write *Art & Fear*, and for most of that time our "book" existed only as cartons of scribbled notes and rough drafts, with nary a publisher in sight.

As a business investment that literary foray into the nature of artmaking made no sense whatsoever — but as an artistic investment it made all the sense in the world. We learned things about ourselves, about our art, and about the common ground we share with other artists. By the time our notes had coalesced into manuscript, we'd *already* reaped the benefits of our effort.

David & I shared a similarly goal-free attitude toward audience — namely, we consciously avoided slanting *Art & Fear* toward any particular audience at all. Instead, we took dead aim on writing a book that *we* would enjoy reading if we happened upon it in a bookstore. We wanted to

create a level playing field, so to speak, where writer and reader could come together as equals. We figured that if there were others out there who thought about the world in the same way we did, they'd like the book too — even though we had absolutely no idea how large that audience might be.

When all is said and done, it's safe to say that most artists (even most professional artists) become neither rich nor famous. An even larger number never quite achieve a body of finished work large enough to show, the expertise to frame and present it, or the connections to the gallery or theatre or publishing world to make something *happen*.

But most strikingly, the vast majority of people who make art don't even call themselves artists. They pursue careers far removed from their passion, and then build in time around the edges for their artmaking. It becomes a quiet, often stoical quest, searching for that seam of silver even though unrewarded for finding it — indeed, unnoticed for even looking.

Yet that very lack of attention from the outside world also brings a healthy realization that fame and fortune are fickle rewards, and that nourishment for our work must come from other parts of our life — from friends and family, and from the satisfaction that comes from the making the art itself. And so yes, *of course* artists today are universally under-recognized and underpaid. But then again, how much money would someone have to pay you in trade for your promise to *never make art again*?

MAKING ART
THAT MATTERS

*I seem to have been only like a boy playing on the seashore,
diverting myself in now and then finding a smoother pebble
or a prettier shell than ordinary, whilst the great ocean
of truth lay all undiscovered before me.*

— Isaac Newton

HEN ALL IS SAID AND DONE, the challenges and uncertainties we face as artists might all come down to this one question: *How do we learn to make art that matters*? That is assuredly the art we all hope to make, yet actual sightings of such work are rare — today, perhaps, even excessively rare. After all, it's not like you can hit Control-P (that's P for *profound*) on your word processor and arbitrarily make it so. Art-making follows an older path. To make art is to follow the vein of silver that forms where your concerns touch the concerns of the world. Only when you align your life

101

with larger worlds is there even the chance that your work will matter. Art that stands the test of time has always reached out to touch humanity's timeless concerns: life, death, love, loss, faith, judgment. Simply put, it takes measure of the human condition:

What is good?

What is true?

What does your art tell us about the way things really are?

Or the way they should be?

We're not talking here about some esoteric art theory — these questions count, and their answers lie close to the heart.

Art reflects the values we live by — as individuals, as a society, as humankind. And that in turn raises another question: *Just what* are *our values today*? Today we're battered by wave after wave of often opposing value systems, each vying for our favor — and in a sign of the times, no doubt, the values that dominate are often tawdry and dispiriting. Some artists find the tabloid grittiness of the world a perfect fit with their sensibilities, but many others find their highest work has little fit with the world they see, much less the world they envision. Those artists face a dearth of outside incentive or reward for pursuing a higher vision. *Beauty* has become a dirty word in the art world — and *sincerity* an embarrassing reminder of gentler times.

Small wonder, then, that the art we make today so often seems ill-fitted to our world. The problem is that

the world is not as we wish. [*No Shit!* — ED.] The vein of silver you choose to work may not be part of this world — it may be part of a better world, or at least a different world. It may even draw upon our collective inheritance of a dimly remembered world.

There's reasonable evidence to show that civilization (at least in forms we readily recognize) stretches back about six thousand years. And we can say with considerable certainty that for the first fifty-seven of those sixty centuries, art played a central role in the daily life of the inhabitants of those cultures. Early cultures perceived the world, in all its good and bad manifestations, as having order and purpose — and when every thing was seen to exist for a reason, *all* art mattered. The simplest of crafts played a role in the most sacred of ceremonies. In ancient Chinese music even individual notes and chords held spiritual significance. In the native Hawaiian language, each syllable carried its own power and meaning. The Navajo blanket is perhaps the archetypal example of the intertwining of art and culture: handmade by members of a community whose religious and cultural values were literally woven into its design, the blanket offered history, tradition, beauty – and warmth.

❦ ❦ ❦

OK, time for a reality check. As my friend Hunter Witherill likes to point out, "Lamenting the loss of the past does little more than disregard (in almost every respect) the realities of the present." Absolutely true.

Film, television, advertising and brand-name offerings from the Gap, Ikea, Pottery Barn and their brethren are the defining art of our era. Consumer Art. Where art was once woven into the social fabric of a culture, today it is woven into the economic fabric. Today anyone can buy a flawless Navajo-style blanket — albeit machine-made and imported from China.

Hunter's razor-sharp intellect is a formidable challenge to my fuzzy-minded romanticism. Like the proverbial tug-o-war between an elephant and a whale, neither of us has enough leverage to overwhelm the other's core beliefs. (But we sure have a lot of fun trying!)

On a slightly different front, Hunter and some of my friends contend that art absolutely *is* a vibrant and positive force in our society today. They point to art as a source of community revitalization through events like neighborhood Open Studio tours and downtown Street Fairs and citywide "First Tuesday" gallery receptions. They show me scores of art announcements in the Calendar section of the Sunday paper. They describe dozens of museum exhibits and gallery openings and live performances they've attended in just the past year or two — and that's not even counting all the art they've *produced* in that same period!

And it's all true. It's all out there, and they've made the most of every opportunity. They immerse themselves in the arts and their lives are immeasurably richer for it. But then again, most of my friends are not exactly at the center of the cultural Bell Curve. Outside the arts community, few people give a passing thought to the value of art in their life (even though — as a hundred channels of cable TV attest — they devote a great deal of time and energy to being entertained by it).

Indeed, it's hard to overstate the importance (and the potential downside) of the entertainment component in artmaking. On the one hand, every successful work of art has some hook for attracting and captivating its audience. Infallible example: the wisdom of the Bible, vividly personalized through its many stories. If all we had instead were a scholarly textbook (or, God help us, a *Powerpoint* presentation) delineating the Bible's philosophical truths, the Good Book would be duller than dog's breath and we'd probably all convert to watching music videos of the *other* Madonna.

On the other hand, the artist faces vexing decisions in trying to strike the right balance between content and presentation—between making art that matters, and making art that entertains. The problem, as both artist and audience discovered ages ago, is that art can be entirely entertaining without being the least bit meaningful. Excavations of Pompeii revealed that pornographic art was wildly popular two thousand years ago. And today — well, the moment *Seinfeld's* backers were able to sell corporate executives on the concept of "a show about nothing", nothing was sacred (so to speak).

The question isn't so much whether art is a form of entertainment, but whether entertaining (or being entertained) is sufficiently rewarding all by itself—independent of content. So here's a test: sometime when you've got ten minutes free, channel surf through the entire hundred-odd offerings on your TV. Then ask yourself: As an artist, how

many of those programs would you have been proud to have created? And as audience, how many would you find engaging enough to watch all the way through? All one hundred? Ninety-four? Two? *None?* If your answers fall toward the low end of that continuum, you may find yourself standing beside me and my friends out at the edge of the Bell Curve.

Nowhere is it inscribed on stone tablets that art made even in the service of God reveals larger truths, or adds greater authenticity, than what is captured in honest work of any flavor. Over the course of our lives, the need repeatedly arises in each of us to make peace with the world, with our work, and with ourselves. When that happens, our internal compass directs us naturally to the course we are meant to take, and "art" issues simply fall away. Coming amid the usual turbulence of life, such periods of grace and clarity (however fleeting) bring as well the realization that making art matter, and making art that matters, are two sides of the same coin. Art will matter when it once again concerns itself with issues that matter, when it once again arises naturally at the points where art and life intersect, when it once again demonstrates that making art is the way we manifest being human.

An Ecology
of Art

*Any time is a good time
to look up from the creek bed at your feet
to the mountains at the horizon.*
— David Bayles

HE Great Basin of the Yellowstone is about as large a piece of intact wilderness as can be found in the temperate latitudes of this planet — a vast forest of pine, fir and spruce stretching from horizon to horizon. Or at least that was so until the summer of 1988, when wildfires raged for months and consumed a million acres of that land. But in one of those curious twists of fate, the Gibbon River (which passes through the territory) at some unheralded point takes an unusual horseshoe bend, and nestled within that protective curve there remain today, unscathed, a small stand of old-growth trees. *Eleven* trees, to be exact.

A stunning photograph of this exact scene appears in David Bayles' book *Notes on a Shared Landscape.*

The forest was not the only casualty of the fire, of course. Among other things, that same forest had provided a home for several thousand generations of birds that nest only in the crowns of its hundred-year-old firs. Consider then that if you were one of those birds, your entire habitable universe after that fire was no longer a thousand square miles of forest. Your entire universe was now eleven trees. *For the next hundred years.*

Now it must count for something that as a species we've been able to grasp the significance of such interconnections within the natural world. But where is our understanding or empathy for such connections in the cultural world — or by extension, the art world? As artists today we find ourselves in the same straits as other endangered species, surviving — when we do — at the margins of our ecosystem. Today neither art nor artist is offered a meaningful role in our culture, and while there's no shortage of political and economic rationalizations for this, it makes no sense whatsoever in an evolutionary sense. Viewed in broad terms, art is an expression of human nature, and human nature is at least partly a product of natural selection. After all, DNA shapes instinct and intellect as readily as it shapes talons and tendons. The traits we associate with artmaking arise from evolutionary sources — and suppressing those traits carries evolutionary consequences.

Before getting too far into this subject I'd like to offer a small disclaimer: I'm an artist, and my observations on

the ecology of art rely far more on the distilled wisdom of scholars and scientists than upon my own training or practice. Personally, I'm more drawn to making art than to researching it, which in turn makes me doubly indebted to others who have exactly the opposite bias. In any serious and time-consuming endeavor, half the battle is simply getting to the work at hand — the other half is recognizing the work you can safely leave to others. After all, if you're a working artist and already face the day-to-day challenge of making headway in your own work, you might reasonably conclude that all the scientific studies in the world will do exactly nothing to get the paint to fall to your canvas any more readily. And chances are you'd be right.

But if not more readily, then how about more meaningfully? In a society where tradition and deeply-held belief systems are in short supply, having a broad overview can help clear the path toward meaningful work. History and tradition bring richness and depth to art, and that fact alone suggests that there *is* value to staying on good terms with your artistic roots. History may not say much about how art gets made, but it can tell us a whole lot about *why* art gets made.

In that regard two names stand out among the relative handful of researchers who have explored the interplay of evolution and artmaking. By general consensus the preeminent authority is Edward O. Wilson, an evolutionary biologist. In *Consilience: The Unity of Knowledge,*

Consilience: The Unity of Knowledge. One of several important books by Edward O. Wilson.

109

Wilson places the breadth of human endeavor (including the arts) within a compelling framework of evolutionary theory. Ellen Dissanayake, the other truly important contributor in the same arena, is author of the meticulously researched (and provocatively titled) book *What Is Art For?* Like Wilson, Dissanayake argues that human nature is shaped by physical (that is, biological) sources, focusing her research specifically on how evolution gave rise to artmaking. And where art historians might define art in terms of styles and periods and masterworks by individual artists, Dissanayake's research shines light on the over arching *process* of artmaking. Moreover she reads the archaeological record with artists' eyes, as it were, lending an unexpected empathy to her interpretation of our all-too-human efforts to make sense of the world around us.

What is Art For?, by Ellen Dissanayake, who expanded her theories on artmaking with two other equally readable books: *Homo Aestheticus*, and *Art & Intimacy*.

Pinpointing the origin of artmaking is itself a judgment call — namely, just when did aesthetics (*beauty? form? rhythm? color?*) first begin to influence the choices our distant ancestors made? The short answer: a *long* time ago. The traits we associate with artmaking were with us long before our ancestors even left the hunter-gatherer stage. Dissanayake cites fragmentary evidence dating back as far as two million years ago, and the evidence becomes progressively more substantial as you move toward the present day. A hundred thousand years ago humans were already engraving artifacts with symbolic markings, and by seventy thousand years ago were ritualistically decorating

their burial sites. Those who embrace creationism or intelligent design might see this as evidence that artmaking is quite literally a sacred activity, guided and blessed by God and given to mankind alone so that we might understand and honor His design. There is, however, a disturbing fly in that theological ointment: some of the early sites which hint of ritual and ceremony addressing the meaning to life and death were created by Neanderthals — an entire species *doomed*, every last one of them, to total extinction. Where does God fit in that scenario?

Returning to the scientific side of the fence, Wilson reasons that we don't inherit a specific "artmaking gene", but rather a more general set of traits that "cause us to see the world in a particular way and to learn certain behaviors in preference to other behaviors". In other words, we're naturally predisposed to make art, perhaps in the same way that Noam Chomsky argues we're hardwired to learn language. And by Dissanayake's accounting, artmaking could never have become so deeply embedded in human culture unless it also offered significant survival value at the purely evolutionary level.

And that evolutionary advantage, by the way, would include both artist *and* audience — there would be no selective value in making art unless the response to art were equally important. Simply put, art is also a part of nature — *our* nature. Human nature and culture evolved together, and for thousands of years art served as the bond that linked, strengthened and validated both. Art was in

I was dead sure when I wrote this passage that some good reader would challenge my skepticism. I'm reserving this sidebar space for that response….

fact so thoroughly integrated into the social fabric that most pre-industrial cultures didn't even have a separate word for "art".

In primitive societies, widely sharing almost *anything* requires direct participation in performances, rituals and traditions that inspire participants to see and hear and, above all, remember. And until at least the end of the Middle Ages, that description would have applied to Western culture as well—namely, every art piece was made to serve some communal purpose, sometimes a visibly important or even holy purpose. Dissanayake argues that widespread literacy fundamentally changed all that, creating a conceptual gulf between modern and traditional societies by changing the very way we *think*. For the first time, it became possible to ask questions that were quite literally inconceivable before written records were kept. The collected knowledge of a culture became accessible to anyone, anytime. Printed material could be studied, compared, annotated, refined, manipulated. Mathematical equations became thinkable. Abstract ideas took on the qualities of "things".

Inevitably, the nature of artmaking itself was profoundly affected as well. By the 18th century, "aesthetics" began developing into a separate and distinct subject for study, and as time passed art increasingly came to be judged by aesthetic criteria alone. Events and places and things that had once provided the purpose for making an art piece became instead merely the subject of an art piece. Self-

expression became an end in itself, and the phrase "art for art's sake" came to be taken as a compliment. In truth it more often represented an abdication of value as artists became the bearers of beauty without responsibility. In contemporary art the subject of a painting is, typically, the painting itself—it doesn't even need to have an independent reason to exist. At its best, contemporary art provides a stunning display of the range of freedom, diversity and pure creativity of the human mind. At its worst we're left with art that offers only imagination without vision, goals without values, individuality without character.

Today the structural changes that have accompanied the rise of the modern world have outpaced by orders of magnitude any equivalent evolution in human nature over the same period—and art had little to do with most of those changes. In the span of a few generations the entire balance of creative and destructive force in the world has changed radically. A century or two ago, tools of mass destruction did not exist — and in a decentralized and largely agrarian civilization there wasn't much any one person *could* destroy anyway. Of course a lone madman in some small town could always burn down a few buildings, but to what advantage? — word of the act might not even travel to the neighboring village. On the other hand, a lone *artist* from some small town—say, Stratford-on-Avon — could create art that would enrich the life of an entire civilization. There was a time when the potential for an individual to do good far outweighed their capacity to do harm.

In today's world that pendulum has swung far to the other extreme. Today the power to destroy vastly exceeds the power to create. Today a lone, self-infected terrorist could cough his way through a crowded subway station and leave a million victims in his wake. And today the voice of the artist has become much fainter, partly because it's lost amidst the general din, but partly also because the voice of art itself is no longer distinctive.

Clearly the model for art that served humanity well for millennia has fallen away in recent times. Where, then, does this leave the individual artist? Seen against the broad sweep of history, how much does the work of any one artist count? Even granting that we learn from history, what exactly is it that we learn? By my accounting, just this: Art is a defining characteristic of culture, and art *making* is a defining characteristic of what makes us human.

Therefore, I would offer you this simple Proposition: that there *is* an ecology of art. And that our job as artists, individually and collectively, is to create a place within our culture—an ecological niche, if you will—that allows us to get on with the work we're meant to do.

A Community
of Artists

*The best way to predict the future
is to invent it yourself.*

— Alan Kay

HERE HAVE ALWAYS BEEN special, actual places where good things not only counted but were woven into the deep fabric of life. A fair percentage of all the great violins and cellos ever made were constructed in the span of a few decades, three centuries ago, in the small Italian village of Cremona. By Stradivarius? Well, yes and no. By him and by all the assistants in his shop — and by Amati and the assistants in his shop, and by Guarneri and all his assistants, and by the other shops in town. It was not simply that violin making was valued in Cremona, it was that violin makers'

lives were part of the deep fabric of life in that town: they bought bread from people they knew as friends, married each others' sons and daughters, shared Sunday Mass, and so on. The Stradivarius violin, assumed by many to be the work of solo genius, was in fact the product of many lives deeply rooted in a particular community.

There was in fact a time when all communities were to some degree "artistic communities". There was once far less separation between art and craft, and since most work *was* craft, there was similarly less distance between art and work. People routinely integrated their ideals into their daily work — a trait that today remains widely practiced *only* in the arts. There was no particular need to sign work, because its focus and importance lay in the subject of the piece rather than the person who made it. Applying a signature or seal was more a statement of pride in good workmanship than a declaration of individuality. The work was important because it was good, not because it was different.

Well, Toto, it doesn't feel like Cremona around here nowadays. Of course I could be wrong, but I'm pretty sure that most of us don't buy our bread from someone who knows and values the art we make. But even if we can't change the whole world in one fell swoop, we can change our own immediate surroundings. If you can identify the conditions that allow art to flourish, you can work toward creating equivalent conditions in your own world. It's entirely within our reach as artists to model our own surroundings to create conditions that — like those in

Cremona — favor our highest efforts. Simply put, if there isn't a place for art in our communities, then we'll have to create better communities.

Implicit in this view is a sense that as artists we need to satisfy a whole list of things in order to make continuing headway in our art. High on that list is an environment that allows whatever-you-have-at-your-core to come to the surface in ways that can be expressed and heard and understood. What's needed is a long-term strategy — one you can build on over the years — for staying in the game. And at least in my experience, reaching that goal means finding – or if necessary creating from scratch – an artistic community you can surround yourself with as a support system for your own artmaking. Over the long run, finding an outlet for showing your art is nowhere near as important as finding an environment conducive to *making* your art.

<div align="center">❧ ❧ ❧</div>

Creating community may begin as a matter of simple necessity. After all, the State is hardly in the business of providing communities for artists, so if that's what you're looking for you're going to have to join with fellow artists and create one yourselves. I've been part of a dozen or more artists' groups over the past thirty-odd years. Some of these have been virtual communities where the interaction is mostly on paper — through correspondence (or more recently, email). In other groups we've held recurring face-to-face gatherings, sometimes to work together

in the field, sometimes to share food and wine and fresh art. Some of these communities have been temporary, others more or less permanent. Some have been carefully planned, others just grew like topsy. Some have even been unintended. And on rare occasions when all the stars were perfectly aligned, sharing something as simple as a weekend workshop brought changes that carried over into the work of a lifetime.

My first effort in that direction came as a direct response to my sense that all the young artists I knew (including myself) were not only powerless, but in fact utterly invisible to the larger world. The opportunity to alter that reality arose when I enrolled in a wilderness photography workshop and found myself sharing two weeks of intense discussion and artmaking the company of a group of like-minded spirits.

Our original group, which we rather self-consciously called The Image Continuum, was comprised of:
David Bayles
Chris Johnson
Robert Langham
Sally Mann
Boone Morrison
Ted Orland

At the time we were all fledgling artists-to-be, lacking a single exhibit or published work among the whole bunch of us — but all eager to make the future happen. Later, back home and suddenly aware of our isolation, it became painfully evident that we needed a mechanism for continuing the sharing process that workshops provide so readily (but so fleetingly). What evolved from that artistic imperative were a series of self-published *Journals*, filled with letters and personal writings from members of the group, and illustrated with original prints. (We couldn't *afford* reproductions!) Our *Journal* never reached the general public, nor even the world of curators or gallery

118

directors. It was for us alone. We printed one hundred copies of each issue — the size of the edition set by our stamina at producing the original prints we tipped-in to each copy — and circulated them within a community composed entirely of our fellow artists.

And significantly, our little group met face-to-face again only twice in its fifteen years of active exchange. But that hardly mattered — the structure itself provided community enough for things to happen that were beyond any of us to accomplish alone. It was, in short, a Community of the Mind. Looking back now, I marvel at all the laughter and tears, all the youthful fervor and sincerity we lavished upon testing the strength of our ideals against the rules of the system. At some level, of course, it was all incredibly naïve, but even now I'm not sure any of us would change a thing. Even if our efforts did not change the world, they did change *us*. Indeed, that is a benefit of all kindred groups — in a sense, it is *the* measure of success.

In recent years my efforts in this direction have taken the form of a classic artists' gathering, loosely modeled after the Paris Salons of the 1920's. It's an easy-to-replicate form: once a month six or eight of us gather and share a pot-luck dinner and wine. Then we clear away the dishes and share work — finished work, in-progress work, experimental work, doomed work, uncomfortable work that's been sitting around bothering us, whatever.

We're not talking about lofty esoteric discourse here. Every idea is fair game for challenge — and woe to the

The Image Continuum *Journal*, 1973-85. Roughly a hundred artists contributed prints or writings to the various issues.

bearer of unexamined propositions! I've known most of these people for many years now, yet whenever we get together to debate ideas about artmaking we still find ourselves changing our position on one question or another, switching sides in the middle of an argument, abruptly seeing an issue in some entirely new light — or all of the above. To say the format "works" is simply to say that it provides benefits that can only come from outside ourselves — among them support, trust and companionship.

This book is itself the beneficiary of just such a support system. Long before this text was coherent enough to even be called a manuscript, it was shared in rough draft form among this trusted circle of *Salonistas*. Some passages met with approval, some with confusion, and some with vigorous (sometimes *rabid*) counter-argument. But that's exactly what's supposed to happen — after all, it's a sharing between artists, not a juried competition.

A community of artists provides a space where it is trusted and accepted that you are trying to make art that matters. That trust and acceptance holds true even when (and perhaps especially when) you are *not* making art that matters. You may not, at the moment, be making good violins. But we all understand what you are trying to do, and because we treasure good violins, we support your efforts through good times and bad. Your goals are not crazy or strange or unrealistic or even unusual to us. Your goals *are* our goals — that's what it means to be part of a community.

❧ ❧ ❧

Successful artistic communities turn out to be highly personal creations, despite some ready-made templates that look promising on paper. University art classes, for instance, bring thousands of aspiring artists together each year, all within a supportive environment specifically designed to help them reach their common goals. That seems like an ideal springboard for the emergence of artists' groups, and in fact every class *is* an artists' group — it's just that it's rarely a long-lived one. Artists' groups thrive when all participants have an equal voice, and with rare exceptions that simply doesn't happen with an instructor standing at stage center.

And beyond that, undergraduate studio art classes typically draw an insoluble mix — true believers who fought successfully to get in, drudges who fought unsuccessfully to escape the course requirement, birds in flight who landed there because it fit their Tues/Thurs class schedule, and the generally bewildered who enrolled out of some vague misunderstanding about what the course was all about. Needless to say, that mix doesn't bode well for continuing the dialog beyond semester's end. And indeed the vanishingly small proportion of classes that continue meeting on their own after the end of the term offers gloomy confirmation that unless you have the right mix of people, *nothing happens*. If the mantra of hot real estate deals is *location location location*, then the mantra of thriving artists' groups is *chemistry chemistry chemistry*.

Successful artists' groups can (and do) differ wildly from one another in size, format, purpose and duration — but in most every case they reflect the *only* structure that could work for that particular group of artists. The tricky part is striking the right balance between common goals and differing sensibilities. Lean too far toward the comfort of shared beliefs, and the result becomes more a mix of personalities than a mix of ideas. Lean too far toward the edginess of opposing philosophies, however, and communication becomes difficult.

Adding to the complexity, even two groups that begin under the same format will soon veer off their own direction as social dynamics come into play. Small groups support give-and-take discussions more easily than large groups, for instance, while large groups just as naturally gravitate toward a presenter/audience format better suited to viewing artwork. Equally, some problems are independent of size. Like: do you have the courage to tell a friend that inviting him to join the group was, well, uh, in retrospect, a mistake? I didn't think so. All things considered, I doubt that even the most ardent control freak could predict, much less control, the evolution of any particular group.

Growth itself seems to generate a certain pressure to put things on a firmer footing, to become more organized. From there it's just a short hop to deciding that the group should set goals or establish rules for discussing artwork, or should elect officers or have sign-ups for

Details, details. Do you even have enough chairs to go around if you invite a dozen people over to your house?

deciding who-brings-what to the potluck. Well, granted that every artists' group needs to find its own direction, its own priorities, its own internal structure — but it's a slippery slope. Personally, when I hear the authoritarian "should" begin creeping into the dialog, I begin edging for the door. Like they say about committees, if you get enough people together they'll agree to do something none of them want to do.

There is, however, another way to view all these issues. Call it the Theory of Benign Chaos: every new artist who joins a group adds another variable into the equation, until eventually the formula for finding the right mix becomes pretty much indistinguishable from trial and error. Surprisingly, this is not a bad thing. Like artmaking itself, there's something invigorating about the unexpected discoveries that accompany the interplay of the new and the familiar among a group of fellow travelers. In our *Salonistas* group, for instance, the person hosting the meeting that month is granted the privilege of inviting one visiting guest artist to join our gathering that evening. We found that adding even that one small surprise element brings new ideas into play, adds intensity to our discussions, and generally keeps everyone on their toes. In the world of artmaking it rarely hurts to throw an occasional wild card into the deck.

Playing that wild card is, in fact, a perfect way to embrace (or at least disarm) the many surprises and uncertainties you're bound to encounter *anyway*. Artists seem to revel

in the melodrama of "artistic risk-taking" — but really, where's the risk? After all, it's not like this is the Middle Ages, when the word DEADLINE had literal overtones. And it's not like artists are designing elevators or airplanes, where one wrong decision can bring real disaster. And by the same token, starting your own artists' group is absurdly easy!

RECIPE FOR AN ARTISTS' GROUP

Call up a few friends you enjoy spending time with.

Invite them over for pizza.

Ask them to bring along a piece or two of their artwork to show everyone what they're up to.

There! Done! You don't even need to tell them you're starting a group. If they find the time together enjoyable (informative, stimulating, profound, or just plain fun) the future will take care of itself. If the idea needs fine tuning, you can always play with the mix or number of participants, the meeting time, the food or whatever, until things mesh.

Often, in fact, the informality of a group is the source of its strength. I belong to one such group, composed largely of seldom-exhibited artists whose professional careers are far removed from the art world. For these people, our monthly gathering is enough to keep artmaking in

their consciousness on a day-to-day basis, and the desire (plus a hint of peer pressure) to have new art to show at the next potluck is enough to keep them in the game on a continuing basis. But curiously, even though we've been meeting now for nearly twenty years, we only recently had our first Group Show together. (In truth the idea had simply never occurred to any of us before – apparently we're not the brightest colors in the paintbox!) Fortunately for posterity, one of our (brighter!) members, Tim Kelly, captured the flavor of our meetings quite eloquently in the Introduction he wrote for that exhibit:

> *We walk through the door calling greetings and balancing two of the evening's three essential elements: Food and Art. There are always at least two mysteries when the art group meets — what will be served and what will be seen. Placed on the counter, entrées are uncovered, sushi unrolled and wine uncorked. This is not a gourmet society, and some of us are well-versed in slicing open a boxed cheesecake or propping a bag of chips against bottled salsa. There's no coordination, only anticipation — or mock complaints — as the evening menu reveals itself. And while we laugh at the memory of the all-dessert evening, we know that, really, the meal is a continuing act of friendship.*
>
> *At some point the meal is finished, the table cleared, and the art comes out. Just as there's no order to the meal, there's no predetermined series of presentations. What we show could be the first glimmering of a new vision, or the further extension of a path long traveled. A painting or photograph or collage or book or print is placed within the spread of a good light. Again there is that sense of anticipation. And then it appears, that third essential piece of the evening: Artists with opinions,*

voicing them. Asking questions, wanting to know what you saw, what you did and how you did it, and where it's taking you. Questioned. Analyzed. Mulled over. We may make art in private, wrapped in our own techniques and ideas, but a piece of art lives when it is shown.

As artists we all need that moment of pushing our work out into the open. That's the intersection of idea and audience. And a real chance that somebody you're not related or married to will actually see (and hopefully appreciate) your work. A group of artists coming together and showing work to one another is one of the best responses to the secret fear that your art may never find an audience. The group feeds that urge to keep going, to keep drawing yourself out. Whatever this community of friends offers — in praise, question, or insight — is significant because, in the end, your art improves. You might even pick up some good recipes.

The community of artists you want is, naturally enough, one in which you're encouraged to become yourself, artistically speaking. In that regard a good community is like a good relationship — a place where your more productive qualities are rewarded, and your self-destructive qualities are not overly indulged. Creating your own community is also a bit like picking a good tennis partner. You want partners who are actually a little more skilled than you, so that you play up to their game — but not so overly skilled that you can't play up to their game.

Your primary contribution to an artists' group is not the artwork itself, but the value you place on making that art.

Simply put, it's the learning-to-make-work-that-matters that matters, not just the work itself. Surround yourself with others who understand that basic truth. Otherwise, serious exchanges devolve into idle chatter over whether the work is saleable or collectable or trend-setting — and that's a task better left to curators and collectors and competitions and other destinations where work is judged. What you're searching for is much rarer: a community where people understand that you are — metaphorically speaking — trying to learn to make great violins.

Few outside audiences understand the importance of the whatever-it-is-that-happens as work is forming. The community of artists around you could well become a valuable destination for your work, perhaps even the primary destination for your work — especially in-progress work that is important to you, but not yet ready for prime time. What you share with your fellow artists is a recognition for the *potential* in what you are all trying to accomplish, both individually and collectively. This is no trivial benefit. How would your vision change if, instead of playing to an audience that validated your art pieces as collectable, you responded to an audience that validated your art making as important?

And by extension, how would your *life* be different?

❦ ❦ ❦

A couple of centuries ago the term "artistic community" would have been a redundancy. You hardly needed a special community to support artists when their art ad-

The stained glass art for the great Rose Window of the Cathedral at Rheims, whose presence marked the spiritual and physical center of the community, was created by anonymous local artisans.

127

dressed the shared concerns of the entire society. It would be useless, however, to ask what our society would look today like if art were as intertwined with daily life as it was in earlier times — if all the necessary changes were to occur, it would no longer *be* our society.

And yet, if the world we've inherited does not favor our highest efforts in artmaking, nowhere is it written in stone that we must settle for things as they are. The world would become a better place if we were to turn away from the current patterns and replace them with better ones. Artists themselves could be the catalyst for such change — but if so, it will not happen by indulging idle fantasies about society magically reuniting around art, but rather by consciously creating actual pieces and actual places where art matters. Joining an artistic community means reaching beyond your studio to share in creating something larger than yourself.

In a sense, communities of artists exist today as exemplars of an attitude toward life that we have allowed to slip away from us. Communities require you to be a human being before you are an artist. This is a good thing. In a community, we come to see the human who made the work as much as we see the work itself. In a community of artists it is understood that the difficulty in making-art-that-matters is in part the difficulty of maintaining our humanity in an uncertain world.

Ultimately, making art that matters is intimately connected with making life itself matter. To paraphrase

Robinson Jeffers, life is worth living when we are doing things worth doing — when we're planting trees, building houses, writing books, raising children. Our highest moments are those in which, by word or deed, we engage important things — and for that task there is no better tool than art. Making art, like having children, is one way of making life worth living. And artworks, like children, are assays of our lives and a measure of the things we hold important. For those who would make art, the basic proposition is crystal clear: finding the work you are meant to do is the central challenge of artmaking — and making that work is the central challenge of life.

finis

AFTERWORD

Oh, I know perfectly well that few readers beyond my small circle of friends and family are likely to pay much heed to this closing page — but hey, they're precisely the ones who *deserve* a page of their own! *The View* owes its very existence to their generous help and encouragement.

So first and foremost, endless thanks to David Bayles, my long-term friend, favorite intellectual protagonist and frequent co-conspirator in the arts. Before moving on to complete his own new book, *Notes on a Shared Landscape*, David was an equal partner in shaping the early structure and direction of *The View* — and indeed his ideas and insights continue to shine through in the finished text.

Then there's our small artists' community of *Salonistas*: Brian Taylor, Saelon Renkes, Chris Florkowski, Gitta Carnochan, Robin Robinson and (again) David. At our potluck gatherings they gamely endured readings from marginally coherent early drafts of this text, and in the boisterous discussions that followed greatly expanded my thinking — and disabused me of some of my favorite

prejudices! — on just about every topic that appears on these pages. And though she lives too far away to attend those monthly gatherings, I especially value the long-running postal/email conversation I've shared with Deb Zeitman, whose ideas and insights flavor many passages in this text.

Other close friends — notably Franco Salmoiraghi, Tim Kelly and Jon Organ — read near-final drafts and helped clarify my garbled thinking on many points. And here on the home front, my wife Frances wins The Really Big Points for single-handedly keeping me afloat throughout the seemingly endless quest to bring this project to closure.

But believe me, despite all the effort that went into this text, *no one* is more aware of its lingering imperfections than I am! On its way to becoming the book you're now reading, *The View* went through at least a half-dozen "final" drafts, each demonstrably better than its predecessor — enough so, in fact, that I'd be genuinely euphoric over each new result. For a few weeks. Then, re-reading the manuscript with fresh eyes, I'd discover a whole new batch of questions that needed answering (and answers that needed questioning). You'd think all that would have ended with *The View's* publication, but in truth the first printing was more akin to the beta version release of some new piece of software. Among other things, sharp-eyed readers quickly uncovered no less than nine — count 'em: *nine*! – typos.

I've also had the good fortune in recent years to be part of two other artists' groups, one hosted by Lisa Rose & Ken Koenig, and the other by Al Weber. Both these groups are godsends – they keep me in the game as an artist.

Typos, however, are just the typ of the iceberg. (Sorry about that.) There is also another — and far more substantial — facet to the feedback process. A hundred-odd pages ago, I proposed that you treat *The View* as a kind of slow-motion conversation, one that would allow for its continued evolution as ideas came in from your side. My theory from the very start was that if all went well — that is, if you stayed in the game and *The View* continued to elude the dreaded Remainder Table — then future editions of this text would become increasingly leavened with insights from readers like yourself. And that is indeed exactly what has happened.

Readers who persevered all the way to this closing page — and that apparently includes you — have offered me a wealth of insights and counter-arguments to the ideas they encountered in this book. The net result is that since *The View's* initial release in 2006, virtually every paragraph in this text has been clarified or revised (or even reversed) in one way or another as a direct result of readers' input. And that conversation continues. I've posted a link on my website — *www.tedorland.com* — for reaching me with your ideas. So there you are. The ball's in your court now....

And since *The View* is self-published and relies *entirely* on word-of-mouth advertising, I also appreciate the reviews that readers have posted on Amazon.com.

GOOD PEOPLE

My thanks again to friends who contributed so many wonderful ideas to the original manuscript of *THE VIEW*, and to readers who have provided ongoing and valuable feedback since the book's publication.

Friends who helped shape the original manuscript

David Bayles	Saelon Renkes	Franco Salmoiraghi
Brigitte Carnochan	Christina Florkowski	Tim Kelly
Brian Taylor	Robin Robinson	Jon Organ

Readers who helped reshape the text into its current form

Huntington Witherill	Eric Biggerstaff	Al Weber
Mark Wainer	Melanie Testa	Bruce Barlow
Maureen Gallagher	Gayle Thomas-Larkin	Holly Roberts
Brooks Jensen	Nevin Mercede	Jeff Turner
Paul Butzi	Lisa Rose	Ladislav Hanka
Ron Hammond	Ken Koenig	Therese Flanagan
Rayna Gillman	Uschi Jeffcoat	Joel Hass
Bruce Bratton	Jan Koutsky	Dick Rose

and many others...

Readers who have contributed reviews on Amazon.com

Amy Zlatic	Susan Reed	Mark Wainer	Karen Tiede	T. Tom

ALSO FROM IMAGE CONTINUUM PRESS

NOTES ON A SHARED LANDSCAPE
Making Sense of the American West
by David Bayles

In this superbly crafted collection of personal writings and photographs, David Bayles explores our complex (and often bungled) love affair with the western landscape. William Kittredge, whose books include *Who Owns The West?*, praises Bayles as a "longtime traveler in the dry interior west...who is profoundly conversant with the region's watersheds, ecosystems and cultures", and concludes, "This is a book anybody who is thinking seriously about the West ought to read and re-read. ...It's honest and useful. That's my idea of high praise."

ART & FEAR
Observations on the Perils (and Rewards) of Artmaking
by David Bayles and Ted Orland

Art & Fear explores the way art gets made, the reasons it often *doesn't* get made, and the nature of the difficulties that cause so many artists to give up along the way. This is a book filled with practical wisdom about what it feels like to sit in your studio, facing your keyboard or canvas, trying to get at the work you need to do. Thanks entirely to word-of-mouth recommendations, *Art & Fear* has become an underground classic within the artistic community, with over two hundred thousand copies now in print. Think of it as an artist's survival guide.

These books are currently available at many independent bookstores. Copies can also be purchased online at Amazon.com, or directly from the authors at www.tedorland.com.

CRITICAL PRAISE FOR ART & FEAR
— the precursor to (and inspiration for) *The View From The Studio Door* —

A wise, pithy and brave appreciation of what is required of an artist. It will become a little classic.
— Peter London, *National Art Education Association*

Rarely does a book manage to be so concise, clear, insightful and thought-provoking all at the same time.
— Light & Dark *Newsletter*

I'm proposing to my co-teacher of the freshman core class that we assign *Art & Fear* as required reading — get them started with this before they have some postmodern French theory crammed into their little heads!
— Professor Linda Connor, San Francisco Art Institute

Filled with anecdotes taken from the world of art, literature and music, *Art & Fear* is a liquidly written overview of how to stay in the game.
— Chris Watson, Santa Cruz *Sentinel*

I can't believe someone wrote a whole book just for *me*!
— Comment overheard from an art student

Astoundingly brilliant (and blessedly short). Easily the keenest insight into making art that I've ever read.
One continuous aahhaaa!
— Kevin Kelly, *Whole Earth Review*